UDO KULTERMANN, Professor of the History and Theory of Architecture at Washington University, St. Louis, Missouri, is the author of many books and articles, including *The New Sculpture, The New Painting,* and *Art and Life.*

KULTERMANN

NEW REALISM

UDO KULTERMANN

new realism

NEW YORK GRAPHIC SOCIETY
GREENWICH ⧖ CONNECTICUT

489453

First published in German under the title RADIKALER REALISMUS
by Verlag Ernst Wasmuth, Tübingen, Germany.

Standard Book Number 8212—0432—7

Library of Congress Catalog Card Number 76—181341

Printed in Germany

Contents

Introduction

The phenomenon of contemporary realism in more recent art can no longer be ignored. Since cubism, formalist critics, applying purist and absolute concepts of abstract art, have sought to denigrate the works of realism. To them such art was of minor quality, or "irrelevant to our fears and hopes for the best modern art" (Philip Leider); in general, realism was regarded as an art of lesser worth. Some purists have even gone so far as to characterize the works of the realists as "inhuman" (R. Constable).

As so often in the history of art, a critic applies criteria he has gained from a certain kind of art to another which is based on different values, and when the original criteria are not satisfied, negative critical conclusions follow. As a consequence the field of perception becomes narrowed, and the vibrant range of contemporary art is reduced to a limited set of easily surveyable concepts which follow a well defined and somewhat artificially marked out path of development. Such narrow criticism, whether from the viewpoint of conceptual, minimal, or pop art will always mean a limitation, if we attribute to this view sole and exclusive validity.

The actual state of contemporary art contradicts this notion of exclusivity. The unbiased eye will discover much more than is permitted by the constricting polemics of the critics and the limited promotion of the galleries. Beside the critically and fashionably sanctioned conceptions of Lichtenstein, Stella, Beuys, and Oppenheim, and op conceptual and minimal art, a new and extremely rich world of realistic works has become increasingly apparent, a world of contemporary realism, selectively but precisely viewed. It also comes as a surprise to learn that this recently recognized movement has been with us for a long time.

Realism as a concept of style has gained increasingly more ground in parallel fields—in philosophy "The New Realism" as a philosophical school, in theater and literature Eli Siegel, as well as in architecture Venturi and Johansen; thus indicating some universally common basis and experience underlying the realist conception; apparently, realistic painting and sculpture have developed out of this context and are not an isolated phenomenon.

These new endeavors are almost exclusively concentrated in the younger generation; most of these artists were born between 1930 and 1940. There are masters of the group, however, who have pursued these realist concepts for many years: Pearlstein (1924), Duane Hanson and Sidney Tillim (1925), Leslie (1927), Goings (1928), and Kanovitz and Laderman (1929). Among the younger artists are Morley and Flack

(1931), Nesbitt (1933), McLean (1934), Robert Cottingham (1935), Estes (1936), Hockney and Clarke (1937), Graham and Sylvia Mangold (1938), and Joseph Raffael (1939). The youngest realist artists include Chuck Close (1940), de Andrea, John J. Moore (1941), Jann Haworth, Bruce Everett and Civitico (1942), Alan Turner (1943), Don Eddy, Kay Kurt and Mahaffey (1944), and Saskia de Boer (1945).

What they have in common with the realists of the older generation has been transformed historically and is more than a simple, direct development of the results of around 1930. Many artists of this new realism were, paradoxically, practitioners of abstract art. Among their teachers, for instance, were Josef Albers, Hans Hofmann, Ad Reinhardt, and Mark Rothko. But a second group of teachers were very influential representatives of a special type of realism, that is, pop art: Oldenburg, Warhol, Thiebaud, Segal and Kienholz. Finally, the first generation of new realists—Bailey, Laderman, Leslie, and Pearlstein—were also teachers of the younger artists.

There exists another kind of realist, more traditional and direct, such as Andrew Wyeth, who seems to be equally realistic. This kind of artist has played no role in formulating the new realism we are discussing here.

Whereas in Wyeth's works we find a further development of traditional realism, without, however, reaching its qualitative height, the new realists search for a basically different method which links them with Stella, Judd, Flavin, and Novros, rather than with O'Keeffe, Sheeler, and Hopper. Like the former, they are concerned with the basic problems of recognition and perception of today's "total situation," with generating anew the objectively given reality, with inquiry into the energies of light and motion, space and surface as well as the structures of animate and inanimate surfaces. Exploring and visually regenerating our world in the pictorial image has been the primal and never-ending theme of art; it is only narrow-minded purists who criticize such themes, which manifest themselves, on the one hand, in the fine modulations of light on a surface and, on the other, in the reality of a nose.

The new view of reality unmistakably started in America, with its centers in California and New York. Bechtle, Goings, Eddy, Cottingham, McLean, Nice, Bond, and Everett live and work on the West Coast. Kanovitz, Nesbitt, Pearlstein, Close, Hanson, Beal, Morley, Clarke, Estes, Flack, Laderman, and Leslie live in New York, which is also an international marketplace both of ideas and of works of art.

European participation has been small in the art of this new realism. Malcolm Morley has moved permanently to the USA and today fits better into the art scene of New York than of England. Jann Haworth, who came originally from California, and Saskia de Boer, woman sculptors living in London, are more inclined in sensibility to New York than to Europe. David Hockney also has shown a tendency in this direction in some of his recent works. In Paris it is mainly Gérard Gasiorowski, along with Peter Staempfli, who, unlike his French fellow painters Monory and Klasen, has developed a particular style out of a basic commitment to the authenticity of the factual. In Italy Pistoletto and Gilardi have followed this form of new realism, but only sporadically, and Bruno Civitico has left Italy for the States. In Germany new realism has taken a somewhat different form, as represented by artists like Koethe in Berlin and Richter in Düsseldorf.

It is clear the most emphatic conception of this new attitude is to be found in the USA, not only among the artists themselves, but also in exhibitions. American exhibitions made the first efforts at showing exclusively works of the new direction: "The Painter and the Photograph" at the University of New Mexico in Albuquerque in 1964; "Aspects of Realism" in the Los Angeles County Museum in 1967; the "Realism Now" exhibition arranged by Linda Nochlin at the Vassar College Art Gallery, Poughkeepsie, New York, in 1968; the exhibition of "Aspects of a New Realism" first presented at the Milwaukee Art Center in 1969 and subsequently in Houston and Akron; the exhibition entitled "Paintings from the Photo" at the Riverside Museum in New York in 1969-70; the "22 Realists" exhibition shown in the Whitney Museum; and, finally, the exhibition called "Beyond the Actual Contemporary California Realist Painting," presented first in the Pioneer Museum and Haggin Galleries in Stockton, California, in 1970. On the other hand, in the exhibition entitled "The American Scene, 1900-1970," presented at the Indiana University Art Museum in Bloomington, the realists, with the exception of Beal and Bechtle, were practically excluded.

Only some of the artists discussed in this book have been found in the exhibitions listed above. This book represents the first groping attempt to deal with the new conception of realism, and it is hoped that it will contribute to this end. More efforts will be necessary and it will take many years to formulate the basis for a critical understanding of the differences in quality and the limits of this art.

My special thanks go to the artists discussed here for their help in collecting the material and the information. Also I feel especially grateful to a number of galleries which were the first to exhibit their work: Molly Barnes Gallery, Los Angeles; Bykert Gallery, New York; Fischbach Gallery, New York; Allan Frumkin Gallery, New York; Kornblee Gallery, New York; Galerie Neuendorf, Hamburg; Jack Glenn Gallery, Corona del Mar; O. K. Harris Gallery, New York; Ester Robles Gallery, Los Angeles; Schoelkopf Gallery, New York; Stable Gallery, New York; Allan Stone Gallery, New York; David Stuart Gallery, Los Angeles; Galerie M. E. Thelen, Cologne; Michael Walls Gallery, San Francisco; Waddell Gallery, New York; and Nicholas Wilder Gallery, Los Angeles.

1. The Present

"The truth will always be new."
Guillaume Apollinaire

Modern culture is a complex, multi-dimensional, ambivalent, and contradictory phenomenon. It is questionable whether anything like a unified style or an all-encompassing concept of art exists such as is predicated for nearly all past historical periods. Many critics in fact, seem certain that our age not only has no unified style, but that the possibility of such a concept is an anachronism, given the conditions of modern culture and ideology.

Just as our modern age is a complex of environments and lacks any discernible social hierarchies in the traditional sense, the art of today exhibits different characteristics as well, which can be distinguished existing side by side. Moreover, seemingly polar opposites are possible and may even condition one another.

We may add that this multi-faceted assemblage of conceptions can only develop in certain centers and that the new realism as earlier described can only develop in areas where so many different kinds of style already exist. This artistic variant needs complex, even hybrid, social symbioses for its formation. These centers could only have developed in such places as California and New York—not in India, Africa, or China, where a different social reality still makes possible the use of stylistic means shaped by traditionally unified concepts, and often leads to a kind of earlier realism without knowing or being able to know other alternatives. And even if some isolated European artists work with this new concept, they live in London, Paris, Turin, Berlin, or Düsseldorf—that is, in those urban centers where there already co-exist different conceptions of style.

Realism in the new sense is only possible in these highly developed intellectual spheres of maximum communication, where only out of the sense of intellectual freedom may a new way of approaching reality be developed. Around 1960 something similar to a sphere of creative freedom in all directions happened in New York and California, where occurred a variety of inspiring situations that determined the culture of the sixties.

We cannot understand this radical new realism without recognizing that it is part of the modern complexity of culture. It is not a traditional or even a reactionary concept of style, as many present-day writers have claimed. Radical realism exists on the same level of modernity as the other progressive concepts of style of the sixties.

Also, contemporary realism is not merely another stylistic development or a phase that follows in the wake of pop art or minimal art, as critics and art historians argue

in attempting to organize creative phenomena into a continuous historical sequence. It is essentially a distinct attitude towards reality alongside others which express our age with equal legitimacy. Dürer, Raphael, Michelangelo, Grünewald, and Bosch were contemporaries and marked a historical situation in the whole complex fullness of their pictorial expressiveness. Similarly today, Stella and Close, Beuys and de Andrea, and Flavin and Morley work side by side, even appreciating each other's differences, recognizing the respective original solutions to similar problems through diverse means. Hence Donald Judd was able to write clear-sightedly on Jackson Pollock, Allan Kaprow on Barnett Newman as a classic, and Yves Klein and Ed Kienholz could work together. Realists like Chuck Close, George Deem, Philip Pearlstein, and Alfred Leslie can be interpreted by some of the formal means and perceptual tendencies of contemporary abstraction.

To speak of realism as one of a variety of different possibilities of artistic expression means to hold an eminently contemporary artistic attitude, which recognizes that it has more in common with all other art forms of today than with the superficially similar realistic forms of the past. This means that artists like Duane Hanson and John de Andrea, Close, Morley, Mahaffey, and Everett are not only contemporaries of Stella, Judd, Flavin, Irwin, and Ron Davis, but also share the same problems with them rather than with artists of now-distant realist traditions, such as Courbet, Dix, Balthus, Sheeler, and Hopper. The realists today in fact are strongly bound to the anti-figurative tendencies of the fifties and sixties and have often developed from them.

Sidney Tillim has already sought to characterize this difference of contemporary realism through the concept of "serialized realism," while Rosalind Constable's completely misleading label of "inhumanists" emphasizes the values of past realist tradition and mistakes the differences between past and present realism for the end and not the means. We must learn to understand that new realist forms have arisen which no longer can be measured by the concepts of the old realistic tradition, even though they may have the same commitment to comprehending the human condition.

Our time, like all others, has features that are not interchangeable, that are only appropriate to us and could only have developed so today. Two of these features are multi-dimensionality and discontinuity, which share some unfathomed and not yet researched mutual qualities. Contemporary realism should be seen and experienced within this context.

Finally, popular photography, made possible by the techniques of modern science and industry, is also important because it enables every person, in principle, to produce pictures of reality. This simple fact, combining aspects of modern science and life, has decisively influenced the new view of reality so powerfully formulated in the works of the new realists.

2. The New Evaluation of Photography

"The true wonder of the world is the visible, not the invisible."
Oscar Wilde

Photography and realist painting begin at roughly the same time, about 1840; and their development runs strikingly parallel. What they have in common is an authentic communication of information about and comprehension of the reality around us. Moreover, photography has a far-reaching sociological function which equally affects our relationship both to reality and to the function of the artist. Since the rise of photography, the singularity of a piece of art as well as the artist's dominant role in society have been questioned. Many painters of the 19th century, like Ingres, Delacroix, Corot, Courbet, Manet, Seurat, Monet, Degas, Cézanne, and Munch, openly or covertly used photographs as a source for their paintings.

In 1862, a lawsuit, which caught the attention of all of Paris, resulted in the verdict that photography was an art. Many artists passionately participated in the case, since both parties, photographers and painters, had presented a variety of arguments to the court. Ingres, the self-appointed advocate for painting, submitted a petition requesting the court to revoke the verdict. He contended that photography consisted merely of a series of mechanical operations, that it was not a product of the mind, and required no artistic study. Ingres' fervent argument against the mechanical reproduction of reality was based on his awareness that realism in art was being challenged.

Realism as a characteristic of the time manifests itself equally well in the works of photographers such as Nadar, Julia Margaret Cameron, Mathew B. Brady, Eadweard Muybridge, Eugène Atget, Clarence H. White, and Alfred Stieglitz, who are now as highly valued artistically as the great painters of their time.

Since, the 1840's, the two media, painting and photography, have existed side by side. Painting was not dead, as the classicist Paul Delaroche had maintained, and at the same time photography was no longer regarded as an inartistic mechanical process. The photographer Eadweard Muybridge even introduced new ways of discovering reality, and he was the first to prove certain facts about motion. Contemporary with Charles Darwin's pioneering theories of the *Expressions of the Emotions in Man and Animals* (1872), Muybridge revealed new spheres of reality through photographic experiments. Thus he influenced scientists as well as artists. Jules Etienne Marey continued Muybridge's research work and laid down the principle for a new theory of motion. From this theory, artists such as Marcel Duchamp and the futurists were able to develop new pictorial foundations.

Thus photography participated in laying the basis for a revolution in painting.

The influence exerted by photography is continually manifest from the pictorial forms of the impressionists to contemporary works, always underlined with the intention of achieving a more precise insight into reality. Hailing photography as one of the most beautiful discoveries of the 19th century, Salomon Reinach concluded in his *General History of Art* (1904): "What artist, even if he had the talent of Van Eyck, would like to compete with the sensitized plate of the camera?"

Photography made possible a new way of comprehending reality which exceeded the perceptive faculties of the human eye to fix and shape detail as well as panorama. Furthermore, new dimensions were discovered which would have been impossible to think of before: for example, in 1856 Nadar took photographs while airborne in a balloon. These aerial photographs show seemingly abstract pictures of the earth's surface, but in truth merely reveal a different and very factual view of reality. Much later, Kasimir Malevich referred to these aerial photographs while seeking to legitimate his own art of suprematism.

A volume of underwater photographs was published by Boten in 1892, done by a technique known since 1855. Furthermore, montage was practiced in the 19th century by pasting over and rearranging various photographs. Microphotography eventually provided insights into the structure of substances that would have been impossible to gain otherwise. As applied to astronomy, photography revealed knowledge, previously denied to human perception, about the moon and other celestial bodies. Moreover, since 1895 X-ray photography has penetrated beneath the surface of man and things and visually laid open their inner structure. Typically enough, Roentgen's results, like those of Muybridge, were at first taken for forgeries.

In the age of abstract art in the sixties, when the link between painting and photography seemed to have been broken, the objects of concrete reality again became the theme of artistic creation in a totally new sense. The photographer David Bernstein could say: "I believe a person can learn from photographers something important about what it means to respect the world." These artists not only applied their method of representing things seen as exactly as possible—that is to say, through the eye of a camera—but also made direct use of photos or photographic copies for their actual artistic creation. Many painters have worked as photographers as well. Above all, however, Warhol's photomechanical method has had an incalculable significance in opening the way to new possibilities of experiencing reality. His total oeuvre is certainly the most important basis for the expansion of contemporary realism. Warhol established the concepts and practices on which one could build a new and modern realism.

By saying, "I don't believe the photograph is the last word in reality," Richard Estes emphasizes the position of contemporary realists who make use of photographs, or rather, of the photographic view of reality, but at the same time find their artistic intentions exceeding these possibilities in certain ways. Together with photographers they attempt to give form, selectively and expressively, to various aspects of contemporary reality. This is the essence of a new iconography.

3. The Subject Matter

"By using photographs I can paint anything I want, whenever I want."

Joseph Raffael

The subject, as well as the formal expression, has been of the utmost significance throughout the history of art. Many themes in traditional art were assumed, taken up almost automatically, but this emphasizes rather than diminishes their fundamental importance to their time. Erwin Panofsky improved upon Aby Warburg's method of iconology—a method developed primarily to understand the total meaning of Italian Renaissance art—to such a degree that the "what" of a picture in all art of the past became the main subject in the field of art history. The "what" of a picture plays a dominant role in contemporary art, particularly in new realism, although this point may be emphatically contested by some realist artists themselves, such as Pearlstein, Morley, and Estes.

What subjects are today's artists preoccupied with? Most striking is a concern with the seemingly trivial, insignificant things of our environment. For many contemporary artists, the attention to a specific subject or object is just a beginning from which the full theme and content of the work can be developed. Experience with this particular subject can often be applied to everything the artist perceives. This has been true of traditional art as well; for example, the "nature morte" of Chardin in the 18th century. Still, Malcolm Morley can write, "I have no interest in subject matter as such or satire or social comment or anything else lumped together with subject matter. ... I accept the subject matter as a by-product of surface." In this case his choice of subject is less conscious, or at least not articulated, but its significance is still fundamental.

But there are limitations: the majestic and grand aspects of reality are no longer as important, nor is the meaning an object has intrinsically, that is, before the artist takes it up. On the contrary, the artists seek with all possible means to avoid the more obviously sanctioned and declamatory bits of reality and to give the banal, unmetaphorical fragments significance through artistic selection and formal presentation. This attempt is, in fact, shared by new realism and contemporary photography.

The world of pop art, on the other hand, was limited insofar as its subject matter could be found in a secondary and prefigured reality, in standardized objects. These objects were depicted as if by reflection in the minds of urban dwellers, helpless before the world of advertising and the mass media. Today's realists, however, seek to rediscover the objects of our visual communication through a direct and individual approach. These artists, too, make use of clichés, photographs, and prefabricated images as subject matter, but the basic concepts have changed.

14

In a transformational process, Morley, Bechtle, McLean, Mahaffey, and Cottingham work by applying clichés of advertising and behavior in their works, just as Warhol made photographs the subject matter of his works. Here, too, the theme is prefabricated, but the artist aims at an original reality and seeks to reproduce its uniqueness and essence by use of the cliché. In a letter to the author, McLean defines his working technique as the attempt "to re-authenticate the photographed event as a pure painting event."

The topics of the radical realists are specified and singular. The people portrayed are individuals by name, age, and certain personal characteristics. Man is no longer the ordinary representative or the statistically created average man of mass media demographics, or the superstar cliché, which deviates from the actual person supposedly represented by the cliché (as in Warhol). Rather, particular attention is paid to the portrayal of an actual face, and this represents and invokes the uniqueness of a person. This result is often achieved by means of close-up and careful portrait rendition, as in the work of Close and Gasiorowski.

The subject of radical realists is the person intimately known, unique, and truly existing. So it becomes clear that most of the younger artists portray almost exclusively people they know well: members of their own families, their own friends, and other people from their everyday surroundings. This applies to painters like Kanovitz, Bechtle, Nesbitt, Gasiorowski, Pearlstein, Close, and Goings, as well as to sculptors such as Hanson, de Boer, Haworth, and de Andrea. Alfred Leslie has written, "Painting the figure has become the most challenging subject the artist could undertake."

In the work of Duane Hanson, reality has been changed as little as possible in order to make this most effective illusion perfect and real: composition no longer means the altering of realistic details, still less the laying bare of energies hidden under the surface of reality; here, composition means the most precise perception of what is real and the greatest possible accuracy. Maximum illusion and maximum reality come onto an even plane. "Supermarket Lady" is the direct materialization of the real figure with all its accessories, while a man clad in everyday clothes, tools, discarded paper, packing material, and garbage of all sorts are part of the total realistic and expressive effect.

This urge to individualize and particularize is true even if groups are the subject. These groups or scenes are identifiable, and not general, stereotyped events. Group pieces by Kanovitz, the scenes by Gasiorowski, and the photographed groups by Morley, Audrey Flack, and Duane Hanson are examples.

Uniqueness and singularity determine the subject matter of still life as well, and the representation of real objects from our everyday surroundings functions in the same way as portraiture, nudes, and group scenes. Anything present in reality may serve as subject matter, and is not limited to the prefabricated clichés of advertising. Consequently the range of topics worth representing is tremendously wide. A new attentiveness is paid even to the smallest details, such as the towel rack in a bathroom in Bruce Everett's painting. This detail becomes a worthwhile subject for a painting since its relation to us is its most important quality.

Landscape as a subject matter of art, often city scenes, again appears, but less

frequently as the urban image determined by advertising during the period of pop art. In Richard Estes's paintings, for instance, the shop windows and street fronts of New York buildings are dominant, and similarly Robert Cottingham's paintings deal almost exclusively with the rooftops of California's sprawling milieu of low-rise houses and office buildings. Paul Staiger's realistic depiction of the houses of famous movie stars, which are sought out as tourist attractions, balances between pop art and the new realism, but its formalism clearly relates his work to the latter.

But the small American town, together with its park and the artificially regular grid of streets, is also a significant landscape. Here, too, both possibilities co-exist: landscape as a prefabricated cliché, as it appears in Morley's "Chateau" (1969), where a photograph functions as visual information even though alienated through a white frame, or landscape in its uniqueness, as it appears in images of small towns in the works of Gabriel Laderman and Bruno Civitico, or America's big cities in the works of Noel Mahaffey, or the French landscape as in the pictures of Gasiorowski. Also influenced by photographs, this documentation includes even pictures showing the surface of the moon—a creative act in itself depicting the uniqueness of the "here" and "now" as in Nesbitt and Hendricks.

Transportation facilities and the communication media, which are so integral to the functioning of our daily life, are also important subjects: cars dominate many of Robert Bechtle's pictures, and Don Eddy concentrates in one series of pictures on just the details of cars; Ralph Goings paints pictures of trucks and buses which convey the omnipresence of transportation; Morley paints scenes of ocean liners, and the airplane appears in the pictures of Estes and Eddy.

Even mythology and the prefabricated image, which George Deem often combines into a single painting, is a subject expressive of the actual physical state of our preserved culture and art. And John Clem Clarke transposes the prefigured world of pictures, mainly through modern contemporary technique, by photographing his friends, who pose in scenes from classic pictures. Here, too, Warhol pointed a new direction with his "Mona Lisa" (1963), and Saskia de Boer's transposing of Leonardo's famous work into a three-dimensional and sculptural Mona Lisa (1970) has been the high point of this development so far.

Realism is the attitude of precise observation, and this applies not only to the periods of realism of past centuries, but also specifically to present-day realism. The way we look at reality has been changed by our modern life, but the artist as well has directed our perception to new things and new ways of seeing. Finally we perceive a new reality through eyes opened for us again by these artists.

As a crucial point in this entire perceptual process, the emotional factor must not be unduly stressed or emphasized, but recognized as already present in the well-balanced representation of all aspects of reality. This emotional aspect is sustained in the formal language of the painting's surface, which constitutes a realistic illusion to the greatest possible degree.

Pop artists, in particular Warhol and Lichtenstein, have newly brought to our attention the reality surrounding us and made us notice the environmental factors of urban life. The world of printing and advertisement, comic strips and TV culture, above all, have been admitted to art as subjects, since they are legitimate expres-

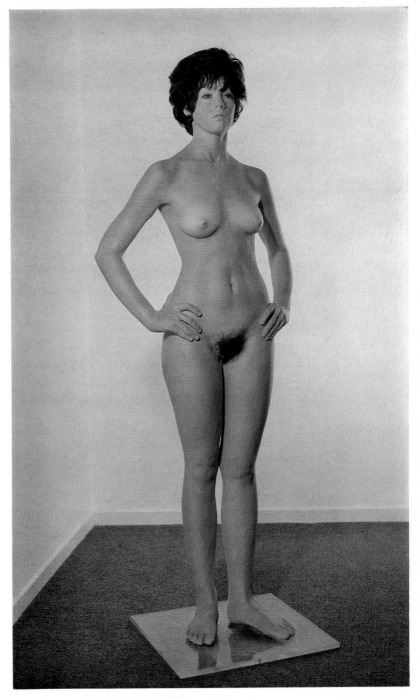

I *John de Andrea* Untitled 1970

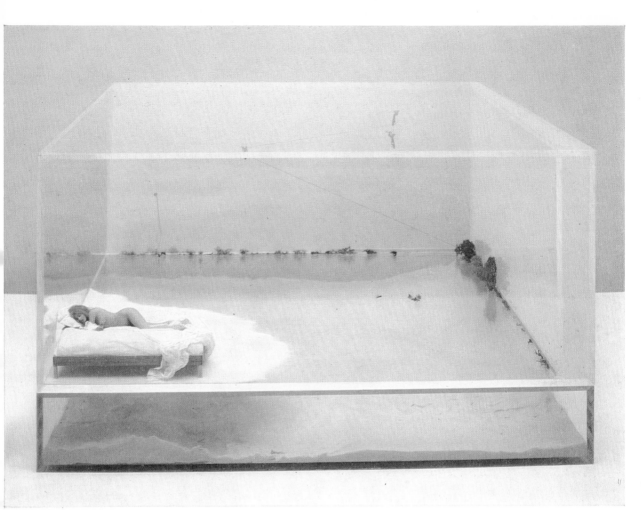

II *Robert Graham* Untitled 1969

III *John Clem Clarke* Untitled 1970

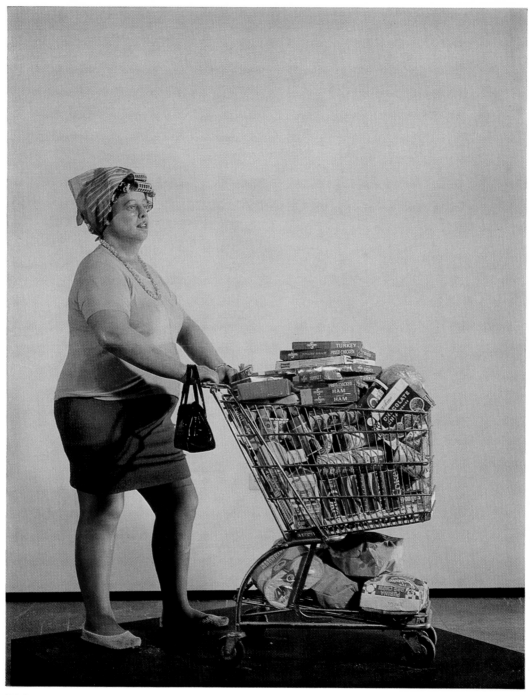

IV *Duane Hanson* Supermarket Lady 1970

sions of our time. But this accentuation, however necessary it might have been for the historical development of modern art, has its own limits. The realists transcend these limits, because for them no defined range exists from which they could not evoke artistic life. Here too, photography is of great help in the choice of topics. Joseph Raffael wrote on the use of photographs in his works as follows: "By using photographs I can paint anything I want, whenever I want. In my Vermont California Studio, I can paint a snowscape in the summer or a wounded Vietnamese. . . ."

This opinion follows wholly the tradition of realism, and as early as the mid-19th century, Gustave Courbet was able to express a similar concept: "The beautiful exists in nature and can be found in the most varying aspects in the center of reality." Everything is worth being dealt with by art, and everything can be represented if it can be painted.

4. The Technique

"You have an idea. You know how it looks. You find it, photograph it, paint it. To paint it is the greatest pain in the ass.
"Or you see something that begs to be placed in your hands and processed. You take it any way you get it."

Howard Kanovitz

The technical process involved in the creation of works of art is connected with the subject matter insofar as the latter can be understood by means of its formal realization alone. Part of the working process is the path which leads from the conception of an idea before carrying it out to the completed work of art. The content of a work of art is the combination of themes carried out by technical processes, and it is the appropriate technique alone which achieves the intended effect. The extreme variety of technical possibilities may be considered a characteristic of contemporary art. In modern sculpture we find almost all technical skills applied, including assemblage and the use of given objects and unformed materials. Almost every technique can be used, such as casting from the human body, modeling in wax, the use of foamy and other easily adaptable materials. On the other hand, traditional materials such as marble, bronze, wood, and stone have less importance.

Differences, however, still exist between sculpture and painting. Sculpture is still three-dimensional, sharing the same space as its onlookers, while painting is constructed on the basis of spatial illusion. However, the two techniques are both largely determined by the characteristics of the photograph, whether the photographs are of art or movie stills as in Jann Haworth's or Saskia de Boer's works, newspaper photographs as in Duane Hanson's sculptures, pin-ups as in Robert Graham's works, or magazine photographs as with the paintings by McLean, Bechtle, and Eddy.

By transposing the photograph of well-known art work into a three-dimensional object the artist may achieve a most startling effect, as Saskia de Boer did with Leonardo's "Mona Lisa." This intrusion into the sphere of the observer becomes intensified even more by the technique of illusionism. This technique is utilized to achieve an extremely shocking effect in the works of de Andrea and Duane Hanson.

John de Andrea works directly with a model, seeking to render it as exactly, authentically, and realistically as possible with materials such as plaster and polyester. For his purpose, photographs are of little value, as he makes clear in a letter to the author: "A photograph is a certain time, place, and person. Trying to force a model to do what a photograph is doing usually results in the thing I try to avoid most—an unnatural position for the model. And most of all, overlooking many of the things that make the model unique." Robert Graham, on the other hand, achieves the effect of alienation by reducing the proportions of his figures and isolating them in glass boxes. Here, a double effect is achieved, as the glass boxes become

quasi-translucent boundaries as well. Both effects combine to incline the viewer to play the role of a voyeur.

The painters make use of all the graphic processes worked out by pop artists, as well as of the techniques of oil painting on canvas. Here, too, both possibilities are determined by the camera: the photographic model is directly or indirectly transposed into the painting medium. Then, the painting's composition is chosen as if it were seen through the camera lens. The artist sees and shapes his object, so to speak, with the lens of the camera. Or, as Warhol has said: "The reason I'm painting this way is because I want to be a machine."

After Andy Warhol had transferred silkscreen techniques into large size, Morley and Clarke used this technique. They made possible the technical improvement of given visual forms without falling back into the cliché of a limited personal style. In this way they achieved freedom over the techniques of painting without sacrificing its advantages. Since Morley is interested in light and surface and in intensity and diffusion of colors, he chooses photographs not for the purpose of reporting but for solving the problems he has set for himself.

Pearlstein, Nesbitt, and Kanovitz still use oil on canvas, often striving for photographic effects. Audrey Flack has described her reasons for the use of photographs as follows:

"I use the photograph because:
- it is a drawing aid.
- it offers me more time and a new kind of relaxed time in which I can study the picture.
- it does not twitch, become irritated, laugh, or move, as human subjects do. I can quietly study it to further the study of reality.
- it freezes space, color, light, and the light source. I can concentrate on color changes, tonality, light striking objects and space, without being interrupted by the actual changes that are continually taking place in the ever-moving world. The frozen photograph lets me study what is taking place in a given moment, minute, or hour—more intensely and for a longer period of time than I can in the actual world of reality.
- it makes inaccessible subjects available for me to paint, such as my painting of the Kennedy motorcade in Dallas five minutes before the assassination. I can calmly study a figure in motion, walking, riding in a car, waving, and so forth.
- it allows me to particularize. I can zoom in and study detail and surface textures.
- it creates the illusion of space by the juxtaposition of form. Perhaps the most important aspect of my use of the photograph, and the most difficult to explain, is space. I am fascinated by the way objects 'butt up' against each other, edges hitting, in front, in back, alongside, line meeting line yet never functioning as line.
- it creates a world of shadows. Shadows create form and they play a role in time and space."

Estes, too, paints directly from photographs as a source and performs the translating process by the choice of the subject matter and its representation: "I use the

photograph because I find it gives me the best references in the subject I choose to paint." But he adds, "I don't believe the photograph is the last word in realism." And Lowell Nesbitt, who himself uses photographs for his pictures, says, "A photographer is not able to bring interpretation or create any formal invention. A painter can and does." Noel Mahaffey, too, uses the opaque projector only up to a certain point and then continues painting freely from the photo: "With the opaque projector, I draw in enough to guide me as reference points, then continue painting from the photo."

The process of transferring from photograph to picture is important rather than the photograph itself, since the photo merely replaces what was earlier called sketch, drawing, or preparatory study. Estes's paintings, for example, transcend the normal photographic perspective through a double view which combines the inside and outside view of an object as well as the relation of both spheres toward each other. In this general aspect they may be compared with Ron Davis's colored stereoscopic pictures. For his picture "Coconut Custard" (1967) Estes even used several photographs, one which showed the inside, and another the outside.

A photograph can first be regarded as a true record of a bit of reality, then as a potential "sketch," and finally be transformed into a complete painting. Joseph Raffael reports on this process as follows: "I keep the photograph in front of me and refer to it constantly. First I draw it very carefully. This can take a long time. I use a brush for this drawing. When the exact composition is crucial I sometimes grid the canvas and the photograph. At other times, by drawing in a more freehand way, I may allow the picture to go where it wants to."

In a letter to the author, Richard McLean describes his working process as follows: "I work almost exclusively from black and white magazine photo reproductions, relying on my own color sense (memory) and some occasional research. The choice of scale and the subsequent pencil tracing on the canvas are made with the aid of an opaque projector. The tracing is then rendered in oil, 'item by item' as it were, over a period of eight weeks ... sometimes a little longer. I manage about five paintings a year nowadays.

"The photograph, as a source, is chosen with great deliberation ... it must first, of course, be 'readable' ... the degree of coolness or neutrality which animates the subject matter, the formal strengths of the image (I sometimes crop and edit out information as well as 'dub in' from other photos), and other considerations both subtle and more personal are all very important in the selection of what to paint."

In cases where the artist seeks to work without semi-mechanical processes, the economy of his artistic devices and the technique which he applies is revealing. Gasiorowski, for example, who almost exclusively uses a small brush to apply a variety of black, achieves a most effective tonality in his paintings through extremely reduced means. Also Chuck Close uses a minimum of color for his large-sized pictures—the larger part of the surface is determined by a white background.

In a certain sense we could speak of "minimal art" here, as Sidney Tillim has, in reference to Pearlstein's and Leslie's figurative compositions. It is not by accident

that artists such as Stella, Judd, and Poons are concerned with similar problems of perception and technique. The most important artists of our time are not so concerned with the differences between figuration and abstraction as with achieving an original artistic solution which is vigorously responsive to the challenges of modern culture.

5. Political Aspects

"There is no such thing as a good work of art that presents a false picture of reality."

Chaim Koppelman

The completely changed attitude of man towards his environment can no longer be ignored, and the responsibility of the individual towards all the various aspects of our environment has been raised to a general consciousness. Sincere efforts towards new solutions in ecology are evident, and the relationship of individuals and groups to one another in confronting this new consciousness is now evolving.

The artist particularly feels challenged as well as responsible for the visual documentation of these spheres of human life. Nothing can be taken for granted any longer. Everything must be questioned and related to personal responsibility. This knowledge and acceptance of responsibility is a healthy step towards change, for it is only through more extensive knowledge that the need for change can be met. The chaos in international relations, as well as in social and private behavior, is confronted by aspirations which measure the extent to which we are prepared to face the challenges of our time.

The concerned artist, who reveals new patterns of behavior, teaches us to recognize reality, and even sharpens our perception of objects. It is not so much participation in political actions and protests, but rather his approach to the subject of inquiry that is important, since he seeks to establish the conditions for recognizing the general meaning of reality.

The realist of 1970, however, does not paint romantic ideals, but seeks to present reality directly and emphatically, while maintaining both coolness and objectivity. The range of his view of reality is exact as well as encompassing. He starts out with a detail and seeks to conceive it as a whole; he begins with any object of his choice. Even a man is only part of a reality experienced objectively and without bias. Along with the picture of man the artist constructs man's environment, his house, the supermarket, the street, the car, and the airplane; with the same detached perception towards real events, he presents the clash between police and demonstrators, as it is shown, for instance, in Duane Hanson's "Riot" and Audrey Flack's "War Protest March."

These pictures are not political propaganda, for they do not reflect any personal point of view on specific political events; rather they are the attempts at an objectified documentation of how the event in question really occurred. The political significance of the picture is expressed far more by the high seriousness which seeks to present a disciplined view of reality.

A comparison with the art of the twenties will clearly show the difference: a work

of art functioned then as a political weapon against a defined political enemy, whereas today a work of art mirrors the greatest possible authentic knowledge of what really happens and exists in reality. In contrast to propagandistic art, which transcends its own boundaries for the sake of political action, and which is still practiced today, only the complex and encompassing representation of reality achieves a deeper and more lasting impression. So Chaim Koppelman says, "I believe that art is not an escape from life. There is no such thing as a good work of art that presents a false picture of reality."

In a more basic sense political art forgoes the possibilities of changing human realities and creating a new scale of values where from a specific situation may originate well-based and responsible political actions. In new realism, in the works of Duane Hanson, for example, we do not have to deal with an immediate involvement, but rather with a more precise presentation of reality, an artistically constituted reality whose transformation, which is reflected through the device of illusion, teaches us to see the other reality.

Only total realization can release impulses for the change of complex unities, whereas the political poster and propaganda device are less effective, and serve better the purpose of a political advocacy rather than achieving a solution. It is only a really new and open conception, which uses many sources of knowledge and has developed effective structures of style, which can close the gap between life and art.

For both art and political action, the basis for change and viable new concepts is inquiry into reality. It is not simply ignorance, but the inability to recognize and define the processes of inquiry which have entangled our previous best efforts, developed irresponsible leadership, and obscured the truth. It is the concepts and values gained by research and the art of precise observation which may determine the course of history, not weapons or armies, or the accumulation of sheer technical, military, or political power.

The technician and the politician serve to execute and carry out ideals postulated by artists, philosophers, and scientists, who define new values for society. Since reality is shaped by these values, it is always the creative and inquiring mind which continually generates the new realities. What we as a society consume is the consequence of what we desire; thus technicians only produce what is already considered our need; politicans, too, function chiefly as instruments of only partially understood mandates.

The responsibility of recognizing and defining the values responsive to these realities belongs to the whole society, and the leaders in this process of investigation should be the artist and the scientist. The scientist communicates this knowledge through logical and provable hypotheses, whereas the artist demonstrates his insight into reality through more subjective means. Both, however, rely on intuition and perception, experiment and discipline, objectivity and tangible forms of imagery. The artist also has the added effectiveness of illuminating the past. This is achieved through his knowledge of eternal forms which do not depreciate, but sustain, our awareness of archetypes.

6. The New Tradition

"The past is always new: it changes continuously as life goes on. Parts of it, seemingly forgotten, emerge again, while others, being less important, plunge into oblivion. The present directs the past as the members of an orchestra."

Italo Svevo

Every important work of art continues and changes the tradition of art. Tradition is not a set concept, but rather something continually fluid. The sum total of all art created in the past has never been a fixed cultural asset which once and for all becomes specifically defined; rather it is a view into the past and is conditioned by the works of contemporary artists.

The art of new realism, too, has influenced our view of the tradition of art history. The concepts of realism in the past must be seen in a new light which will give us new insight into historical development in general. The line of ancestry established by contemporary realists teaches us to reconsider this aspect of art history from this point of view. Typically enough, the newly-formed tradition legitimating to-day's realism focuses on those periods and styles which resisted and opposed abstraction and reduction.

While the expressionists objected to the realism of the 19th century and the renaissance tradition, they admired the visionary art of the Middle Ages, the East, and other exotic forms. From the viewpoint of contemporary realism, however, we can newly evaluate the Italian Renaissance and the 19th century, and discover new and often unexpected sources of realism in such early renaissance or late medieval artists as Giotto, the Joseph-Master of Reims, the Naumburg Master, and Giovanni Pisano.

Again, among the 16th-century artists we can make new discoveries today, not so much with great visionaries such as Breughel, Bellange, and El Greco, who were discovered by artists of expressionism, but rather with Bronzino, Palissy, and Holbein. The importance of a Caravaggio to the beginning of the baroque period of Peter Paul Rubens, Jan Liss, and Diego Velázquez was never questioned. But there are also such artists as Vermeer and Zurbarán, whose radical realism approaches perhaps more closely that of present-day artists. In addition there are many undercurrents of the 17th and 18th centuries which catch our attention: the experiments with colored wax sculptures as well as with medallion portraits and pieces from cabinets of curiosities. The vedute of Canaletto and Guardi, which aim at authenticity and sometimes show dependence on the *camera obscura,* often seem close to modern realism, especially in contrast to their contemporaries.

Nineteenth-century photography, formerly regarded as a technical innovation, has undergone a revolutionary new evaluation. It is now possible to acknowledge the achievements gained in the two fields of photography and painting by judging

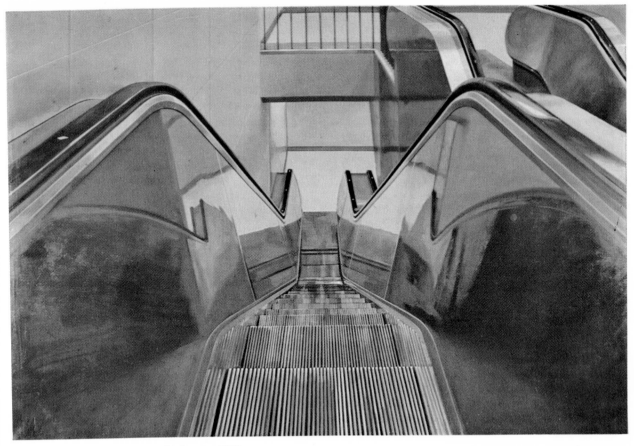

V *Richard Estes* Subway Stairway 1970

them with comparable criteria; so we find them standing on the same level of mutual and interchangeable connections, proving the influence photography exercised on painting. Today's evaluation of 19th-century art has demonstrated that the assumption of a simple development of painting from David and Ingres to Delacroix, Courbet, Manet, and Cézanne can no longer exist, and that it was a far more complex process which applied to the diverse phenomena of the 19th century. Realistic painters such as Tissot, Knopff, Redon, Rops, and Vallotton may be integrated into the chain of tradition and put on the same level with those masters already considered to be classics. Even painting and sculpture of the salons, which until recently were downgraded and denigrated as being insincere, can now be judged with objectivity and assigned to the traditional development of art.

All this has led to an enrichment of the new tradition. In contrast to the puristic bias, our judgment has been freed in favor of the realistic conception which had been excluded from the realm of painting for being too diffuse and documentary. This re-evaluation, which continues in the 20th century, views artists in a new light —artists who for a long time were considered as provincial since they did not fit into the cliché of abstract purism. Essentially, painters like Sheeler, Demuth, O'Keeffe, Dix, Schrimpf, Kanoldt, Schad, and Frossberg who were influenced by photography and film art were no longer subject to the criticism and obscurity accorded them by the school of abstract art. Their methods are now regarded as legitimate stylistic possibilites of the thirties. And finally, more objective research can be done on artists such as Grosz and Heartfield, for instance; even painters and artists of Russia's and Germany's dictatorial regimes are now being objectively researched and no longer considered only for their political topicality.

Earlier in this century was raised the question of the legitimacy of modern realism. In 1924 Hans Hildebrandt wrote in his book *The Art of the 19th and 20th Centuries* the following: "And it is only for the superficial observer that neo-realism has anything to do with naturalism or portraitism; the triumph of those who themselves did not develop and fancied that the artists after erroneous and adventurous journeys returned to their own 'correct' position, is in vain. Portraitism was the last and most extreme consequence of the principle of an elemental artistic technique and overloaded form with so many demands placed on it that it broke. For the neo-realist the composition of a picture is nothing more than a merely pictorial element securing the artistic principle of unity which he seeks to fulfill on the basis of 'natural seeing' and using all the treasures of our earthly realism. Nature is looked at with eyes experienced in seeing forms; the eye has been sharpened in the products of technology and the works of absolute art as well. Photography, which has for a long time been an important factor, made us discover that what seems to be unformed material to our untrained senses, may have the greatest effect, order and perfection as well, and may sometimes even be the most beautiful. The world of the neo-realists is much richer than the world of the naturalists ever was."

Since 1960 the newly gained freedom has made possible a further re-evaluation. All the popular pictorial forms and contents which for such a long time were downgraded as lesser genres, were won back by pop art. Today's danger comes from the other extreme, which leads to a possible misunderstanding of abstract and

non-representational forms. We must learn to understand that this contribution, too, was a necessary and legitimate expression of its time and, paradoxical as it may sound, lives on in the works of the new realists.

Nothing is lost in the development of art; rather, different aspects are newly emphasized, overshadowing others. In this continuously dynamic field of change, viable new forms are marked by vitality and integration, and the ultimate direction is not predictable. Nevertheless, its development is always sustained by the past. Our contemporary realists, too, have forged a new art by comprehending both traditional styles and modernity.

List of Illustrations

COLOR PLATES

I *John de Andrea* Untitled 1970
170×70×40 cm
Neue Galerie, Sammlung Ludwig,
Aachen

II *Robert Graham* Untitled 1969
Galerie Neuendorf, Hamburg

III *John Clem Clarke* Untitled 1970
O. K. Harris, New York

IV *Duane Hanson*
Supermarket Lady 1970
Neue Galerie, Sammlung Ludwig,
Aachen

V *Richard Estes* Subway Stairway 1970
Allan Stone Gallery, New York

VI *Saskia de Boer* Mona Lisa 1970
Collection Udo Kultermann, Leverkusen
Photo: Saskia de Boer, London

VII *Robert Cottingham* c. h. 1970
78″×78″
Courtesy the artist
Photo: Robert Cottingham, Los Angeles

VIII *Ralph Goings* Untitled 1970
O. K. Harris, New York
Photo: O. K. Harris, New York

BLACK AND WHITE ILLUSTRATIONS

1 *Joseph Raffael* Picasso 1969
79,5″×61,5″
Oil on canvas
Gallery Reese Palley, San Francisco

2 *Joseph Raffael* Cheyenne 1969
80″×60″
Oil on canvas
Collection Dr. and Mrs. Oakley Frost
Photo: Gallery Reese Palley,
San Francisco
Schopplein Studio, San Francisco

3 *Joseph Raffael* Pomo 1970
79″×59,5″
Oil on canvas
University Art Museum, Berkeley,
California
Courtesy Gallery Reese Palley,
San Francisco
Photo: Schopplein Studio,
San Francisco

4 *Chuck Close* Nancy 1968
108″×84″
Acrylic on canvas
Collection Jeff Byers
Photo: Kenneth Lester, New York

5 *Chuck Close* Self Portrait 1968
108″×84″
Acrylic on canvas

Walker Art Center, Minneapolis,
Minnesota
Photo: Kenneth Lester, New York

6 *Chuck Close* Phil 1969
108″×84″
Acrylic on canvas
Whitney Museum, New York
Photo: Courtesy the artist

7 *Chuck Close* Frank 1969
108″×84″
Acrylic on canvas
Minneapolis Institute of Art,
Minneapolis, Minnesota
Photo: Kenneth Lester, New York

8 *Chuck Close* Keith 1970
108″×84″
Acrylic on canvas
Private Collection, New York
Photo: Courtesy the artist

9 *Chuck Close* Richard 1969
108″×84″
Acrylic on canvas
Neue Galerie, Sammlung Ludwig,
Aachen
Photo: Kenneth Lester, New York

10 *John de Andrea* Untitled 1970
Polyester resin polychromed
O. K. Harris, New York

11 *John de Andrea* Untitled 1970
Polyester resin, polychromed
O. K. Harris, New York

12 *John de Andrea* Untitled 1971
Life-size
Polyester resin, polychromed in oil
Courtesy the artist

13 *John de Andrea* Untitled (Detail) 1970
Life-size

Polyester resin, polychromed in oil
O. K. Harris, New York
Photo: J. P. Witkin, New York

14 *John de Andrea* Untitled 1971
Life-size
Polyester resin
Courtesy the artist

15 *John de Andrea* Untitled 1971
Life-size
Polyester resin
Courtesy the artist

16 *Lowell Nesbitt* Studio Floor Nude
1969
70″×104″
Oil on canvas
Collection Dr. and Mrs. Jacob Weinstein
Photo: Lilo Raymond, New York

17 *Lowell Nesbitt* Nude with Ladder
1969
60″×48″
Oil on canvas
Stable Gallery, New York
Photo: Lilo Raymond, New York

18 *Philip Pearlstein*
Woman Reclining on Couch 1966
54″×71.75″
Oil on canvas
Courtesy Allan Frumkin Gallery,
New York
Photo: Nathan Rabin, New York

19 *Philip Pearlstein*
Model in the Studio 1965
53.5″×71.75″
Oil on canvas
Courtesy Allan Frumkin Gallery,
New York
Photo: Nathan Rabin, New York

20 *Philip Pearlstein*
Models in the Studio 1967
60″×72″
Oil on canvas
Courtesy Allan Frumkin Gallery,
New York
Photo: Nathan Rabin, New York

21 *Philip Pearlstein*
Two Female Models 1967
50″×60″
Collection Mr. and Mrs. Stephen
B. Booke, New York

22 *Robert Graham* Untitled (Detail) 1970
Courtesy Galerie Neuendorf, Hamburg

23 *Robert Graham* Untitled (Detail) 1970
Courtesy Galerie Neuendorf, Hamburg

24 *Jack Beal* Peace 1970
84″×212″
Oil on canvas
Allan Frumkin Gallery, New York

25 *Jack Beal* Madison Nude 1967
60″×76″
Oil on canvas
Allan Frumkin Gallery, New York

26 *Jack Beal* Sofa with Sondra 1968
70″×78″
Oil on canvas
Allan Frumkin Gallery, New York

27 *Jann Haworth* Maid 1966
66″×20″
Nylon, Kapok, Stocking
Robert Fraser Gallery, London

28 *Lawrence Dreiband* Untitled 1969
70″×80″
Oil/Acrylic Airbrush
Courtesy the artist

29 *Alex Katz* Ada with Sunglasses 1969
34″×48″
Oil on canvas
Courtesy Fischbach Gallery, New York

30 *Robert Bechtle* Fosters' Freeze 1970
49″×60.5″
Oil on canvas
O. K. Harris, New York
Photo: J. P. Witkin, New York

31 *Duane Hanson* Football Players 1969
Oil/Polyester/Fiberglas
Neue Galerie, Sammlung Ludwig,
Aachen

32 *Duane Hanson* Untitled 1969
Life-size
Mixed Media
O. K. Harris, New York

33 *Duane Hanson* Baton Twirler 1971
Life-size
Fiberglas, resin mixed media
O. K. Harris, New York
Photo: E. Peterson, New York

34 *Duane Hanson* Bunny 1970
Life-size
Fiberglas
O. K. Harris, New York
Photo: E. Petersen, New York

35 *Duane Hanson* Woman Reading 1970
Life-size
Polyester resin, fiberglas, mixed media
Collection Reinhard Onnasch, Berlin
Photo: E. Peterson, New York

36 *Duane Hanson* Tourists 1970
Life-size
Fiberglas, Polyester with polychromed oil
O. K. Harris, New York
Photo: E. Peterson, New York

37 *Duane Hanson*
Portrait of Melvin Kaufmann 1971
Life-size
Fiberglas, mixed media
Collection Melvin Kaufmann

38 *Duane Hanson* Hardhat 1970
Life-size
Polyester/Oil and mixed media
O. K. Harris, New York
Photo: E. Peterson, New York

39 *Duane Hanson* Riot 1968
Life-size
Polyester-Fiberglas cloth
Courtesy the artist

40 *Duane Hanson* Riot (Detail) 1968
Life-size
Polyester-Fiberglas cloth
Courtesy the artist

41 *Alfred Leslie* Self Portrait 1966/1967
108″×72″
Oil on canvas
Whitney Museum, New York

42 *Alfred Leslie* Constance West 1969
Oil on canvas
Collection Mr. and Mrs. Robert C. Scull,
New York
Photo: G. Clements, New York

43 *Robert Bechtle* French Doors 1965
72″×72″
Oil
Collection Allen Weller, Univ. of Illinois
Courtesy the artist

44 *Robert Bechtle* Hoover Man 1966
72″×54″
Oil
Courtesy Lee Nordness Galleries,
New York
Photo: G. Clements, New York

45 *Audrey Flack* Family Portrait 1969/70
40″×60″
Oil on canvas
Riverside Museum, New York
Photo: Dan Lenore, New York

46 *Robert Bechtle* '61 Pontiac 1968/1969
60″×84″
Oil on canvas
Whitney Museum, New York
Courtesy the artist

47 *John Clem Clarke* Three Graces 1970
175×228 cm
Oil on canvas
Aachen
Neue Galerie, Sammlung Ludwig,
Courtesy Galerie M. E. Thelen, Köln

48 *John Clem Clarke* Three Graces 1970
96″×79″
Oil on canvas
O. K. Harris, New York
Photo: E. Peterson, New York

49 *John Clem Clarke*
Judgement of Paris IV 1969
85″×138″
Oil on canvas
Milwaukee Art Center, Milwaukee
Courtesy O. K. Harris, New York
Photo: Dan Lenore, New York

50 *John Clem Clarke*
Small Bacchanale 1970
74″×89″
Oil on canvas
O. K. Harris, New York
Photo: E. Peterson, New York

51 *Gérard Gasiorowski*
Le voyage de Mozart à Prague 1969
130×163 cm
Oil on canvas
Galerie M. E. Thelen, Köln

52 *Gérard Gasiorowski*
Dix secondes conscientes 1970
163×130 cm
Oil on canvas
Galerie M. E. Thelen, Köln

53 *Gérard Gasiorowski*
Dans les campagnes on voit partout
des bicyclettes ... 1966
162×130 cm
Acrylic on canvas
Courtesy the artist

54 *Gérard Gasiorowski* Untitled 1965
Oil on canvas
Courtesy the artist

55 *Douglas Bond* Ace I 1968
64″×44″
Acrylic on canvas
Courtesy the artist

56 *Douglas Bond* Dollie Ruth 1970
84″×55″
Acrylic on canvas
Courtesy the artist

57 *Howard Kanovitz*
A Death in Treme 1970/71
120″×240″×180″
Acrylic on canvas on wood
Courtesy the artist

58 *Howard Kanovitz* A Death in Treme
(Detail) 1970/71
75.5″×84″
Acrylic on canvas on wood
Courtesy the artist
Photo: Geza Fekete

59 *Howard Kanovitz* A Death in Treme
(Detail) 1970/71
72″×70″
Acrylic on canvas on wood
Courtesy the artist

60 *Harold Bruder*
Luncheon at Hay-Meadows 1969
40″×60″
Oil on canvas
Collection Mr. and Mrs. L. B. Wescott,
Rosemont, N. J.

61 *Harold Bruder*
Canyon Encounter 1967
48″×48″
Oil on canvas
Collection Mr. and Mrs. Donald B. Straus,
New York
Courtesy Forum Gallery, New York

62 *Audrey Flack* War Protest March 1969
Oil on canvas
Courtesy the artist
Photo: J. D. Schiff, New York

63 *Duane Hanson* War 1967
Life-size
Fiberglas and Polyester resin
O. K. Harris, New York
Photo: Shunk-Kender, New York

64 *Yehuda Ben-Yehuda* Untitled 1970
Life-size
Plastics
Courtesy the artist

65 *Yehuda Ben-Yehuda* Untitled 1970
Life-size
Plastics
Courtesy the artist

66 *Richard McLean* Untitled 1969
60″×72″
Acrylic on canvas
Collection Monroe Myerson,
Long Island, N. Y.
Photo: E. Peterson, New York

67 *Richard McLean*
Still Life with Black Jockey 1969

60″×60″
Oil on canvas
Whitney Museum, New York
Courtesy the artist
Photo: Schopplein Studio,
San Francisco

68 *Richard McLean*
All American Standard Miss 1968
60″×60″
Oil on canvas
Collection Mr. Rene de Rosa
Napa, California
Courtesy the artist
Photo: Schopplein Studio, San Francisco

69 *Richard McLean*
Blue and White Start 1968
60″×60″
Oil on canvas
Courtesy the artist
Photo: Schopplein Studio, San Francisco

70 *Richard McLean*
Synbad's Mt. Rainier 1968
60″×60″
Oil on canvas
Collection Mr. and Mrs. John H. Slimak,
Chicago
Photo: Schopplein Studio, San Francisco

71 *Noel Mahaffey* Untitled 1969
3×3 feet
Oil on canvas
Courtesy the artist

72 *Noel Mahaffey* Untitled 1969
6×6 feet
Acrylic on canvas
Philadelphia Museum of Art
Courtesy the artist

73 *Malcolm Morley*
Vermeer — Portrait of the Artist
in His Studio 1968

105″×87″
Acrylic on canvas
Collection E. Millington-Drake
Courtesy Kornblee Gallery, New York

74 *George Deem*
An American Vermeer 1970
93″×42″
Oil on canvas
Courtesy the artist
Photo: O. E. Nelson, New York

75 *John Clem Clarke*
Vermeer — Woman with Jug 1970
38″×46″
Oil on canvas
Courtesy Kornblee Gallery, New York

76 *William Bailey* Egg Cup and Eggs 1970
30″×36″
Oil on canvas
Courtesy Robert Schoelkopf, Gallery
New York
Photo: John D. Schiff, New York

77 *Kurt Kay*
For All Their Innocent Airs, They Know
Exactly Where They're Going 1968
5×12 feet
Oil on canvas
Courtesy Kornblee Gallery, New York
Photo: Jay Cantor, New York

78 *Howard Kanovitz* Canvas Backs 1967
71″×50″
Oil on canvas
Courtesy the artist
Photo: John D. Schiff, New York

79 *Howard Kanovitz* Crown Jewel 1970
31.75″×17.75″
Polymer acrylic
Courtesy Galerie M. E. Thelen, Köln

80 *Stephen Posen* Brown 1970
96″×89″
Oil on canvas
O. K. Harris, New York
Photo: E. Pollitzer, Garden City, N. Y.

81 *Stephen Posen* Green 1970
80″×76″
Oil on canvas
O. K. Harris, New York
Photo: E. Pollitzer, Garden City, N. Y.

82 *John J. Moore* Cylinders 1969
60″×72″
Oil on canvas
Courtesy the artist

83 *John J. Moore* Yellow Table 1970
52″×60″
Oil on canvas
Courtesy the artist

84 *Richard Joseph* Blue Roll 1968
66″×61″
Oil on canvas
Courtesy Dell Gallery, Chicago

85 *Richard Joseph* Drawing Table 1968
60″×60″
Oil on canvas
Courtesy Richard Feigen Gallery,
New York
Photo: E. Pollitzer, Garden City,
New York

86 *Howard Kanovitz*
The Painting Wall
and Water Bucket Stool 1968
93″×115″
Polymer acrylic on canvas
Courtesy the artist

87 *Lowell Nesbitt* Plaster and Pipes 1967
60″×60″
Oil on canvas

Collection Thomas Jefferson,
Los Angeles, California
Photo: E. Pollitzer, Garden City, N. Y.

88 *Sylvia Mangold* Floor Corner 1969
46″×60″
Oil on canvas
Courtesy the artist

89 *Yvonne Jacquette*
The Barn Window Sky 1970
50″×67.5″
Oil on canvas
Courtesy Fischbach Gallery, New York

90 *Cecile Gray Bazelon* Studio Two 1970
54″×54″
Oil on canvas
Courtesy Robert Schoelkopf Gallery,
New York
Photo: John D. Schiff, New York

91 *Lowell Nesbitt*
Table and Ladder 1966
90″×60″
Oil on canvas
Collection Udo Kultermann, Leverkusen
Photo: Lilo Raymond, New York

92 *Paul Sarkisian*
Untitled (Mendocino) 1970
114.75″×198.5″
Acrylic on canvas
Collection Mr. Walter Scott Woods, Jr.,
San Francisco
Courtesy Michael Walls Gallery,
San Francisco
Photo: Schopplein Studio, San Francisco

93 *Alan Turner* Untitled 1969
15″ × 22.5″
Acrylic on canvas
Collection Mary Glazebrook
Courtesy Galerie Neuendorf, Hamburg

94 *Bruce Everett* Doorknob 1970
84″×57″
Oil on canvas
Collection Mr. and Mrs. William Ching,
Tustin, California
Courtesy Jack Glenn Gallery,
Corona del Mar, California

95 *Bruce Everett* Towel Rack 1970
67″×94″
Oil on canvas
Courtesy Jack Glenn Gallery,
Corona del Mar, California

96 *Bruce Everett* Untitled 1969
67″×67″
Oil on canvas
Courtesy Jack Glenn Gallery,
Corona del Mar, California

97 *Don Nice* Turnip 1967
90″×44″
Acrylic on canvas
Courtesy Allan Stone Gallery, New York

98 *Joseph Raffael* Autumn Leaves
(Homage to Keturah Blakeley) 1970
85″×85″
Oil on canvas
Courtesy Gallery Reese Palley,
San Francisco
Photo: Schopplein Studio, San Francisco

99 *Alex Katz* Iris 1967
36″×72″
Oil on canvas
Courtesy Florist's Transworld Delivery
Association, Detroit

100 *Gabriel Laderman* Still Life 1963/64
40″×50″
Oil on canvas
Collection Manes
Courtesy the artist
Photo: John D. Schiff, New York

101 *Gabriel Laderman* Still Life
(Homage to David "Death of Marat"), 1969
40″×50″
Oil on canvas
Courtesy the artist
Photo: John D. Schiff, New York

102 *Alan Dworkowitz* BSA 1971
19.25″×24″
Oil on canvas
Courtesy the artist

103 *Alan Dworkowitz* BSA 1971
22″×22″
Oil on canvas
Courtesy the artist

104 *John Salt* Untitled 1968/1969
Oil on canvas
Courtesy O. K. Harris, New York
Photo: Dan Lenore, New York

105 *John Salt* Blue Interior 1970
45.5″×57″
Oil on canvas
Courtesy O. K. Harris, New York
Photo: J. P. Witkin, New York

106 *John Salt* Arrested Vehicle
(Writing on Roof) 1970
53″×78″
Oil on canvas
Courtesy O. K. Harris, New York
Photo: J. P. Witkin, New York

107 *Alfred Leslie*
The Killing of Frank O'Hara 1969
48″×72″
Oil on canvas
Courtesy Richard Bellamy and the
Noah Goldowsky Gallery, New York
Collection Mr. and Mrs. Robert Orchard
St. Louis, Mo.
Photo: P. R. Eells, Milwaukee

108 *Don Eddy* Volkswagen: R. F. 1970
66″ × 48″
Oil on canvas
Courtesy the artist

109 *Don Eddy* Volkswagen: R. F. 1970
48″ × 66″
Oil on canvas
Courtesy the artist

110 *John Salt*
Arrested Vehicle Broken Window 1970
Oil on canvas
Private Collection
Courtesy O. K. Harris, New York
Photo: J. P. Witkin, New York

111 *Don Eddy* Jeep L. P. 1970
48″ × 66″
Oil on canvas
Courtesy the artist

112 *Richard Estes* Store Front 1968
48.5″ × 61″
Oil on masonite
Courtesy Allan Stone Gallery, New York

113 *Richard Estes* Untitled 1970
Oil on canvas
Courtesy the artist

114 *Ralph Goings* Airstream 1970
60″ × 85″
Oil on canvas
Aachen, Neue Galerie, Sammlung Ludwig
Photo: E. Peterson, New York

115 *Ralph Goings* Untitled 1969
45″ × 63″
Oil on canvas
Galerie Zwirner, Köln

116 *Robert Bechtle* '67 Chrysler 1967
36″ × 40″
Oil on canvas

Collection Alfred Heller, Kentfield,
California
Courtesy the artist

117 *Robert Bechtle* '60 T-Bird 1967/1968
72″ × 96″
Oil on canvas
Collection University Art Museum,
Berkeley, California
Courtesy the artist

118 *Malcolm Morley*
First Class Cabin 1965
Liquitex on canvas
45.5″ × 59.5″
Courtesy Kornblee Gallery, New York
Photo: Eric Pollitzer

119 *Malcolm Morley*
"Amsterdam" in front of Rotterdam 1966
Liquitex on canvas

120 *Don Eddy* Untitled 1969
Oil on canvas
Courtesy the artist

121 *Don Eddy* Untitled 1969
Oil on canvas
Courtesy the artist

122 *Ralph Goings*
Burger Chef Chevy 1970
Oil on canvas
Collection Arthur Cohen, New York
Courtesy the artist

123 *Ralph Goings* McDonald's 1970
41″ × 41″
Oil on canvas
Courtesy O. K. Harris, New York
Photo: E. Peterson, New York

124 *Malcolm Morley*
Racetrack 1969/1970
70″ × 88.5″

Acrylic on canvas with encaustic
Neue Galerie, Sammlung Ludwig, Aachen
Courtesy O. K. Harris, New York
Photo: M. Varon, New York

125 *Malcolm Morley*
Coronation and Beach Scene 1969
88.5″×88.5″
Acrylic and magnacolor on canvas
Kornblee Gallery, New York

126 *Paul Staiger* The Home of
Randolph Scott, 156 Copley Place 1970
48″×60″
Acrylic on canvas
Courtesy of Michael Walls Gallery,
San Francisco
Photo: Schopplein Studio San Francisco

127 *Paul Staiger* The Home of
Kirk Douglas, 707 North Cañon
Drive 1970
48″×60″
Acrylic on canvas
Collection Mr. A. Alfred Taubman,
New York
Photo: Schopplein Studio, San Francisco

128 *Richard Estes* Untitled 1967
69″×48″
Oil on canvas
Courtesy Allan Stone Gallery, New York

129 *Richard Estes* No. 2 Broadway 1968
49″×66″
Oil on masonite
Collection Lawrence Groo, New York
Courtesy Allan Stone Gallery, New York

130 *Richard Estes* Untitled 1970
Oil on canvas

131 *Richard Estes* Untitled 1970
Oil on canvas

132 *Robert Cottingham* Untitled 1969
78″×78″
Oil on canvas
Courtesy the artist

133 *Robert Cottingham* Untitled 1969
78″×78″
Oil on canvas
Courtesy the artist

134 *Robert Cottingham* Untitled 1969
78″×78″
Oil on canvas
Courtesy the artist
Photo: Jack Koehler, Los Angeles

135 *Robert Cottingham* c. h. 1970
78″×78″
Oil on canvas
Courtesy the artist
Photo: Jack Koehler, Los Angeles

136 *Robert Cottingham*
Woolworth's 1970
78″×78″
Oil on canvas
Courtesy the artist
Collection Mr. and Mrs Edward Bianchi,
New York
Photo: Jack Koehler, Los Angeles

137 *Robert Cottingham*
Discount Store 1970
Oil on canvas
Courtesy the artist
Collection Mr. Dennis Horlick,
Los Angeles
Photo: Jack Koehler, Los Angeles

138 *Robert Cottingham* Holiday's 1970
Oil on canvas
Courtesy the artist
Collection Home Savings and Loan,
Los Angeles
Photo: Jack Koehler, Los Angeles

139 *Gabriel Laderman*
View of Florence 1962/63
48″×92″
Oil on canvas
Courtesy the artist
Photo: John D. Schiff, New York

140 *Bruno Civitico*
Florence — San Lorenzo 1968
22.5″×27″
Oil on canvas
Courtesy Fischbach Gallery, New York

141 *Gabriel Laderman* Downriver 1964
40″×50″
Oil on canvas
Courtesy Robert Schoelkopf Gallery,
New York
Photo: John D. Schiff, New York

142 *Gabriel Laderman*
View of Baton Rouge
with St. James Cathedral 1967
40″×50″
Oil on canvas
Courtesy the artist
Photo: John D. Schiff, New York

143 *Robert Bechtle*
Four Palm Tress 1969
45″×52″
Oil on canvas
Courtesy O. K. Harris, New York
Photo: E. Peterson, New York

144 *Douglas Bond* Saguaro 1970
84″×66″
Acrylic on canvas
Courtesy the artist

145 *Noel Mahaffey*
St. Louis, Missouri 1971
60″×72″
Oil on canvas
Courtesy the artist

146 *Noel Mahaffey*
Portland, Oregon 1970
42″×54″
Oil on canvas
Courtesy the artist

147 *Noel Mahaffey*
St. Paul, Minnesota 1970
30″×36″
Oil on canvas
Courtesy the artist

148 *Noel Mahaffey*
Minneapolis, Minnesota 1970
42″×54″
Acrylic on canvas
Courtesy the artist

149 *Noel Mahaffey* Waco, Texas 1970
24″×30″
Oil on canvas
Courtesy the artist

150 *Lowell Nesbitt*
Work Stages — V. A. B. 1970
77″×77″
Oil on canvas
The Detroit Art Institute
Courtesy the artist
Photo: Lilo Raymond, New York

151 *Lowell Nesbitt* Lift-Off 1970
90″×70″
Oil on canvas
Neue Galerie, Sammlung Ludwig,
Aachen
Courtesy the artist
Photo: Lilo Raymond, New York

152 *Lowell Nesbitt* Moon Craters 1969
60″×80″
Oil on canvas
Courtesy the artist
Photo: Lilo Raymond, New York

Artists' biographies

Abbreviations

S = Education
R = Residence
T = Teaching position
* = Birthplace

John de Andrea
* 1941 Denver, R: Denver
S: University of Colorado, Denver
1970 O. K. Harris Gallery, New York

William Bailey
* New York, R: New Haven
1968 Robert Schoelkopf Gallery, New York

Cecile Gray Bazelon
* Cleveland, Ohio, R: New York
S: Syracuse University
1971 Robert Schoelkopf Gallery, New York

Jack Beal
* 1931 Richmond, Virginia, R: New York
S: William and Mary College, Norfolk;
Art Institute, Chicago;
University of Chicago 1965, 1967, 1968
1965, 1967, 1968 Allan Frumkin Gallery,
New York
1966, 1969 Allan Frumkin Gallery, Chicago
Lit: A. Dennis: Jack Beal, in: Artforum
Sept. 1967
Scott Burton: Jack Beal's Tables,
in: Art Scene Apr. 1969

Robert Bechtle
* 1932 San Francisco, R: Berkeley
S: University of California; California College
of Arts and Crafts
1960 Barrios Gallery, Sacramento, California
1960 Lawrence Drake Gallery, Carmel,
California
1959, 1964 San Francisco Museum of Art
1967 University of California, Davis

Saskia de Boer
* 1945 Amsterdam, R: London
S: Kunstakademie, Amsterdam

Douglas Bond
* California, R: Pasadena

Harold Bruder
* 1930 New York, R: New York
S: Cooper Union, New York
1962 Robert Isaacson Gallery, New York
1965 Kansas City Art Institute
1968, 1969 Forum Gallery, New York

Bruno Civitico
* 1942 Dignano, Italia, R: New York
S: Rutgers University, Newark;
Pratt Institute, New York

John Clem Clarke
* 1937 Oregon, R: New York
S: Oregon State College; Mexico City
College; University of Oregon
1968 Kornblee Gallery, New York
1970 O. K. Harris Gallery, New York
1970 M. E. Thelen Galerie, Köln
1970 Michael Walls Gallery, San Francisco

Chuck Close
* 1940 New York, R: New York
S: Yale University, New Haven; University of
Washington, Seattle; Akademie der
Bildenden Künste, Wien
1970, 1971/72 Bykert Gallery, New York
Lit.: C. Nemser: An Interview with
Chuck Close, in: Artforum Jan. 1970
C. Nemser: Presenting Chuck Close,
in: Art in America Jan.–Febr. 1970
A. Spear: Reflections on Close, Cooper and
Jenny, in: Arts Magazine May 1970

Robert Cottingham
* 1935 Brooklyn N. Y., R: Los Angeles
1968, 1969, 1970 Molly Barnes Gallery,

Los Angeles
1970 Jack Glenn Gallery, Corona del Mar,
California
1970 O. K. Harris Gallery, New York

George Deem
* 1932 Vincennes, Indiana
R: Cortona, Italia
1963, 1968 Allan Stone Gallery, New York
1963 Art Institute, Chicago
1969 Galerie M. E. Thelen, Essen

Laurence Dreiband
* 1944 New York, R: Los Angeles
S: Art Center College, Los Angeles
1970 David Stuart Gallery, Los Angeles

Alan Dworkowitz
* 1946 New York, R: New York
S: Fairleigh Dickinson University;
Art Students' League;
Yale University, New Haven

Don Eddy
* 1944 Long Beach, California,
R: Santa Barbara
S: University of California, Santa Barbara;
University of Hawaii;
Fullerton College, Fullerton
1970, 1971 Molly Barnes Gallery, Los Angeles
1970 Galerie M. E. Thelen, Essen
1970 Ester Bear Gallery, Santa Barbara
1971/72 French and Company, New York

Richard Estes
* 1936 Evanston, Illinois, R: New York
S: Art Institute, Chicago
1968, 1969 Allan Stone Gallery, New York
1968 Hudson River Museum, New York

Bruce Everett
* 1942 California, R: Reseda, California
S: University of Iowa;
University of California, Santa Barbara

Audrey Flack
* 1931, R: New York
S: Cooper Union in New York;
Yale University in New Haven;
Cranbrook Academy; New York University
1959, 1963 Roko Gallery, New York

Gérard Gasiorowski
* 1930 Paris, R: Paris
1970 Galerie M. E. Thelen, Köln
1970 Galerie M. E. Thelen, Essen

Ralph Goings
* 1928 Corning, California, R: Sacramento
S: California College of Arts and Crafts;
Sacramento College
1960, 1962 Artists Cooperative Gallery,
Sacramento
1966 Candy Store Gallery, Folsom
1968 Artists Contemporary Gallery,
Sacramento

Robert Graham
* 1938 Mexico-City, R: Los Angeles
S: San Jose State College;
San Francisco Art Institute
1966, 1967, 1969 Nicholas Wilder Gallery,
Los Angeles
1967 Galerie M. E. Thelen, Essen
1968, 1971 Galerie Neuendorf, Hamburg/
Köln
1968, 1969 Kornblee Gallery, New York
1969 Whitechapel Art Gallery, London
Lit.: Robert Graham, Köln 1969

Duane Hanson
* 1925 Alexandria, Minn., R: New York
S: Cranbrook Academy of Art; University of
Washington, Seattle
1970 O. K. Harris Gallery, New York

Jann Haworth
* 1942 Hollywood, R: London
S: University College, Los Angeles;
Slade School, London
1966 Robert Fraser Gallery, London
Lit.: M. Amaya: Cooling the Shape. The
Strange World of Jann Haworth,
in: Sculpture International Febr. 1967
C. Finch: Jann Haworth and Nicholas Monro,
in: Art International 1, 1967

Yvonne Jacquette
* 1934 Pittsburgh, R: New York
S: Rhode Island School of Design
1971 Fischbach Gallery, New York
Richard Joseph
* 1939 Chicago, R: Los Angeles
1968 Dell Gallery, Chicago

Howard Kanovitz
* 1929 Fall River, Mass., R: Köln
S: Rhode Island School of Design
1962 Stable Gallery, New York
1964 Fall River Art Association
1966 Jewish Museum, New York
1969, 1971 Waddell Gallery, New York
1970 Galerie M. E. Thelen, Köln

Alex Katz
* 1927 New York, R: New York
S: Cooper Union, New York; Skowhegan
School of Painting and Sculpture
1961 Stable Gallery, New York
1962 Martha Jackson Gallery, New York
1966 David Stuart Gallery, Los Angeles
1967 Fischbach Gallery, New York
1970 Galerie Brusberg, Hannover
1971 Galerie M. E. Thelen, Köln
Lit.: E. Denby: Katz in: Art News Jan. 1965
W. Berkson: Alex Katz' Surprise Images,
in: Arts Magazine Dec. 1965

Kay Kurt
* 1944 Dubuque, Iowa, R: Duluth, Minn.
S: University of Wisconsin
1970 Kornblee Gallery, New York

Gabriel Laderman
* 1929 Brooklyn, R: New York
S: Hans Hofmann School, New York;
Atelier Hayter, Paris;
Accademia di Belle Arti, Firenze
Brooklyn College;
Cornell University, Ithaca, New York
T: Queens College, Flushing, N. Y.
1964, 1967, 1969 Robert Schoelkopf Gallery,
New York
1966 Louisiana State University

Alfred Leslie
* 1927 New York, R: New York
S: New York University
1951, 1952, 1953, 1957 Tibor de Nagy Gallery,
New York
1957, 1958 Robert Keene Gallery,
Southampton, N. Y.
1960, 1961, 1962 Martha Jackson Gallery,
New York
1961 David Anderson Gallery, New York
1962 Holland-Goldowsky Gallery, Chicago
1969 Noah Goldowsky Gallery, New York

Noel Mahaffey
* 1944 St. Augustine, Florida, R: Philadelphia
S: Dallas Museum of Fine Arts;
Pennsylvania Academy of the Fine Arts
1970 Marian Locks Gallery, Philadelphia

Sylvia Mangold
* 1938 New York, R: New York
S: Cooper Union, New York;
Yale University, New Haven

Richard McLean
* 1934 Hoquiam, Washington,
R: San Francisco
S: California College of Arts and Science,
Oakland; Mills College, Oakland
1957 Lucien Lambaudt Gallery,
San Francisco
1963 Richmond Art Center
1964, 1966, 1968 Berkeley Gallery,
San Francisco
1965 Valparaiso University, Valparaiso,
Indiana
1967 University of Omaha, Nebraska

John J. Moore
* 1941 in St. Louis, Mo., R: Philadelphia
S: Washington University, St. Louis;
Yale University, New Haven

Malcolm Morley
* 1931 London, R: New York
S: Royal College of Art, London
1964, 1967, 1969 Kornblee Gallery, New York
L. Alloway: The painting of
Malcolm Morley, in: Arts and Artists, Feb. 1967

Lowell Nesbitt
* 1933 Baltimore, R: New York
S: Tyler School of Fine Art, Philadelphia;
Royal College of Art, London
1958, 1969 Baltimore Museum of Art
1964 Corcoran Gallery of Art, Washington,
D. C.
1965, 1966 Rolf Nelson Gallery, Los Angeles
1965, 1966, 1967, 1970 Henri Gallery,
Washington, D. C.
1965, 1966 Howard Wise Gallery, New York
1966, 1967, 1968, 1969, 1971 Gertrude Kasle
Gallery, Detroit
1968, 1969 Stable Gallery, New York
1969 Galerie M. E. Thelen, Essen
1970 Galerie M. E. Thelen, Köln

41

Lit.: Graphic edition „Cape Kennedy '69",
with an introduction by Wernher von Braun
und Udo Kultermann, Essen 1970

Don Nice
* 1932 Visalia, California, R: New York
S: University of Southern California;
Yale University, New Haven
1963 Richard Feigen Gallery, New York
1967 Allan Stone Gallery, New York

Philip Pearlstein
* 1924 in Pittsburgh, R: New York
S: Carnegie Institute of Technology,
Pittsburgh; New York University
1955, 1959 Tanager Gallery, New York
1956, 1957, 1959 Peridot Gallery, New York
1960, 1965, 1969 Allan Frumkin Gallery,
Chicago
1962, 1963, 1965, 1967, 1969, 1970
Allan Frumkin Gallery, New York
1962 Kansas City Art Institute
1965, 1966 Ceeje College, Los Angeles
1965 Reed College, Portland
1967 Bradford Junior College
1968 Carnegie Institute, Pittsburgh
1970 Georgia Museum of Art, Athens, Georgia
1971 Galerie M. E. Thelen, Köln
Lit.: H. Kramer: Academic or Radical?,
in: Art in America Apr. 1963
S. Tillim: Philip Pearlstein and the New
Philistinism, in: Artforum May 1966
W. P. Midgette: Philip Pearlstein and the
Naked Truth, in: Art News Oct. 1967
L. Nochlin: The Ugly American,
in: Art News Sept. 1970
D. Daris: The Eyewitness,
in: Newsweek Nov. 16, 1970
U. Kultermann: Philip Pearlstein, Köln 1971

Michelangelo Pistoletto
* 1933 Biella, R: Torino
1960, 1963 Galleria Galatea, Torino
1964, 1967 Galerie Sonnabend, Paris
1964, 1966, 1970 Galleria Sperone, Torino
1971 Studio Santandrea, Milano

Stephen Posen
* St. Louis, Mo., R: New York
S: Washington University St. Louis;
Yale University, New Haven
1971 O. K. Harris Gallery, New York

Joseph Raffael
* 1933 Brooklyn, R: San Francisco
S: Cooper Union, New York;
Yale School of Fine Arts, New Haven
1965, 1966, 1968 Stable Gallery, New York
1970 Reese Palley Gallery, San Francisco
Lit.: R. Pincus-Wiffen: Allusive Structure,
in: Artforum Dec. 66
W. Wilson: Paintings of Joe Raffael in the
Franciscan Mood,
in: Art and Artists Sept. 1966

John Salt
* 1937 Birmingham, England, R: New York
S: Birmingham College of Art;
Slade School of Fine Arts, London
1965, 1967 Ikon Gallery, Birmingham
1966 Birmingham University
1969 Zabriskie Gallery, New York
1970 Gertrude Kasle Gallery, Detroit
1970 O. K. Harris Gallery, New York

Paul Sarkisian
* 1928 Chicago, R: Pasadena
S: Art Institute, Chicago;
Otis Art Institute, Los Angeles;
Mexico-City College
1968 Pasadena Art Museum
1969 Corcoran Gallery, Washington, D. C.
1970 Michael Walls Gallery, San Francisco
1970 Santa Barbara Museum of Art

Alfons Schilling
* Wien R: New York
1969 Richard Feigen Gallery, New York

Paul Staiger
* 1941 in Portland, Oregon,
R: Los Gatos, California
S: Northwestern University;
University of Chicago;
California College of Arts and Crafts
1969 Michael Walls Gallery, San Francisco

Yehuda Ben-Yehuda
* 1933 Bagdad, R: New York
S: Hebrew University, Jerusalem
1969 O. K. Harris Gallery, New York

Allan Turner
* 1943 New York, R: London
S: City College in New York;
University of California, Berkeley

Bibliography

H. Hildebrandt: Die Kunst des 19. und 20. Jahrhunderts, Wildpark-Potsdam 1924

J. Cary: Art and Reality, New York 1958

V. Barker: From Realism to Reality in Recent American Painting, Lincoln, Nebr. 1959

R. Hamann und J. Hermand: Naturalismus, Berlin 1959

P. Selz: New Images of Man, New York 1959

C. Greenberg: Art and Culture, Boston 1961

J. Janis und R. Blesh: Collage, New York 1961

D. Ashton: The Unknown Shore, Boston 1962

H. Gernsheim: Creative Photography, London 1962

E. Rosenthal: The Changing Concept of Reality in Art, New York 1962

H. Wescher: Die neuen Realisten und ihre Vorläufer, werk 1962

J. Reichardt: Some Aspects of the Human Image, Metro 8, 1963

J. Reichardt: Pop Art and After, Art International 2, 1963

P. Restany: The New Realism, Art in America 1, 1963

R. Rosenblum: Roy Lichtenstein and the Realist Revolt, Metro 8, 1963

D. G. Seckler: Folklore of the Banal. An Introduction to the Provocative New Realism, in: What is American in American Art?, edited by J. Lipman, New York 1963

H. Kramer: Realists and Others, Arts Magazine 1, 1964

A. Neumeyer: The Search for Meaning in Modern Art, Englewood Cliffs, N. J. 1964

B. Newhall: The History of Photography, New York 1964

H. Richter: Dada. Kunst und Antikunst, Köln 1964

S. Tillim: The New Avantgarde, Arts 2, 1964

M. Amaya: Pop Art, London 1965

J. Claus: Kunst heute, Hamburg 1965

P. Francastel: La réalité figurative, Paris 1965

H. Geldzahler: American Painting in the Twentieth Century, New York 1965

B. Rose: Filthy Pictures, Artforum May 1965

J. Rublowski und K. Heyman: Pop Art, New York 1965

S. Tillim: Further Observations on the Pop Phenomenon, Artforum November 1965

G. Battcock, Editor: The New Art, New York 1966

E. Crispolti: La Pop Art, Milano 1966

A. Gowans: The Restless Art, New York 1966

A. Kaprow: Assemblage, Environments and Happenings, New York 1966

U. Kultermann: Die Sprache des Schweigens, quadrum 20, 1966

L. Lippard: Pop Art, New York 1966

L. Nochlin: Realism and Tradition in Art, 1848–1900, Englewood Cliffs, N. J. 1966

E. Pignon: La quête de la réalité, Paris 1966

N. Ponente: La peinture américaine, Genève 1966

J. Thyssen: Grundlinien eines realistischen Systems der Philosophie, Bonn 1966

H. Aach: A Painter's Quarrel on Use of Photographs, Art Journal Winter 1967/1968

L. Alloway: Art as Likeness, Arts Magazine May 1967

A. Boatta: Pop Art in USA, Milano 1967

G. H. Hamilton: Painting and Sculpture in Europe, 1880–1940, Baltimore 1967

U. Kultermann: Neue Dimensionen der Plastik, Tübingen 1967

G. Laderman: Unconventional Realists, Artforum November 1967

B. Rose: American Art Since 1900, New York 1967

S. Tillim: Scale and the Future of Modernism, Artforum October 1967

E. Bertonati: Aspetti della Nuova Oggettività, Milano 1968

E. Billeter: The Living Theatre, Bern 1968

B. Brecht: Über den Realismus, Leipzig 1968

P. Brook: The Empty Space, London 1968

R. Constable: Style of the Year. The Inhumanists, New York December 16, 1968

L. Nochlin: The New Realists, Realism Now, Vassar College Art Gallery, Poughkeepsie, N. Y. 1968

Realismus in der Malerei der 20er Jahre, Kunsthalle Hamburg 1968

P. Restany: Les Nouveaux, Réalistes, Paris 1968

Return to the Challenge, Time 12. 1. 1968

R. Vance: Painting Lists, Art and Artists February 1968

A. S. Weller: The Joys and Sorrows of Recent American Art, Urbana 1968

Aesthetic Realism, Ted van Griethausen, Editor, New York 1969

G. Celant: Ars Povera, Tübingen 1969

J. A. Franca: Métamorphose et métaphore dans l'art contemporain, Paris 1969

H. und A. Gernsheim: The History of Photography, New York 1969

J. Grotowski: Toward a Poor Theatre, New York 1969

M. Kirby: The Art of Time, New York 1969

U. Kultermann: Neue Formen des Bildes, Tübingen 1969

E. Lucie-Smith: Late Modern, New York 1969

J. Russel, S. Gablik: Pop Art Redefined, New York 1969

R. Schechner: Public Domain, New York 1969

S. Tillim: The Reception of Figurative Art, Artforum February 1969

S. Tillim: A Variety of Realism, Artforum Summer 1969

M. Volpi: Arte dopo il 1945, USA, Bologna 1969

P. Meiermair, Edit.: Hommage an das Sweigen, Innsbruck 1969

S. Bann: Experimental Painting, London 1970

H. Buddemeier: Das Heraufkommen der Photographie im Spiegel der ästhetischen Diskussion, München 1970

R. Crone und W. Wiegang: Die revolutionäre Ästhetik Andy Warhols in Kunst und Film, 1970

D. Davis: Return to the Real, Newsweek 23. 2. 1970

R. Graham: 1963–1969, Köln 1970

T. Grochowiak und H. I. C. Jaffé: Zeitgenossen, Recklinghausen 1970

M. Heidegger: Die Kunst und der Raum, Genève 1970

G. Kepes, Hrsg.: Der Mensch und seine Dinge, Genève 1970

U. Kultermann, Leben und Kunst, Zur Funktion der Intermedia, Tübingen 1970

Die Kunst unserer Zeit, Genève 1970

J. Monte: 22 Realists, Whitney Museum, New York 1970

J. Weber: Pop Art, Happenings und neue Realisten, München 1970

J. E. Youngblood: Expanded Cinema, New York 1970

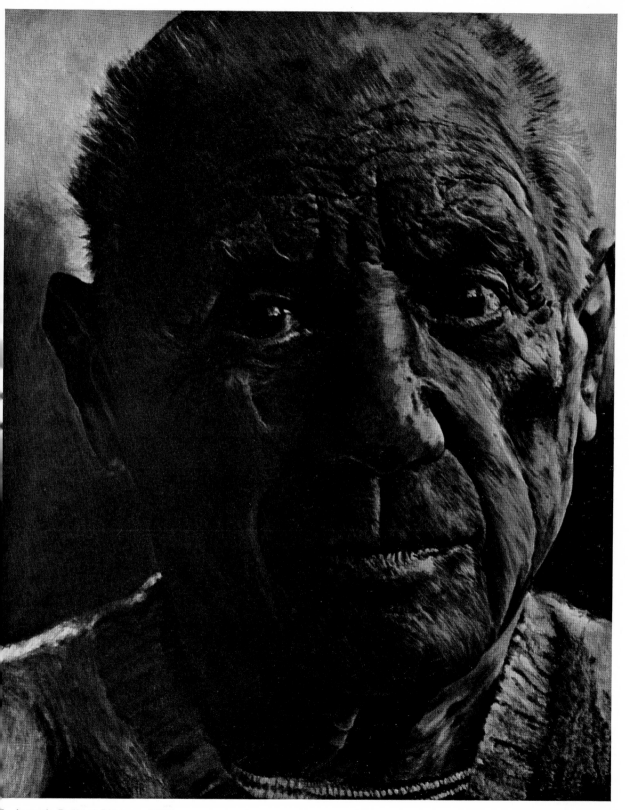

Joseph Raffael Picasso 1969

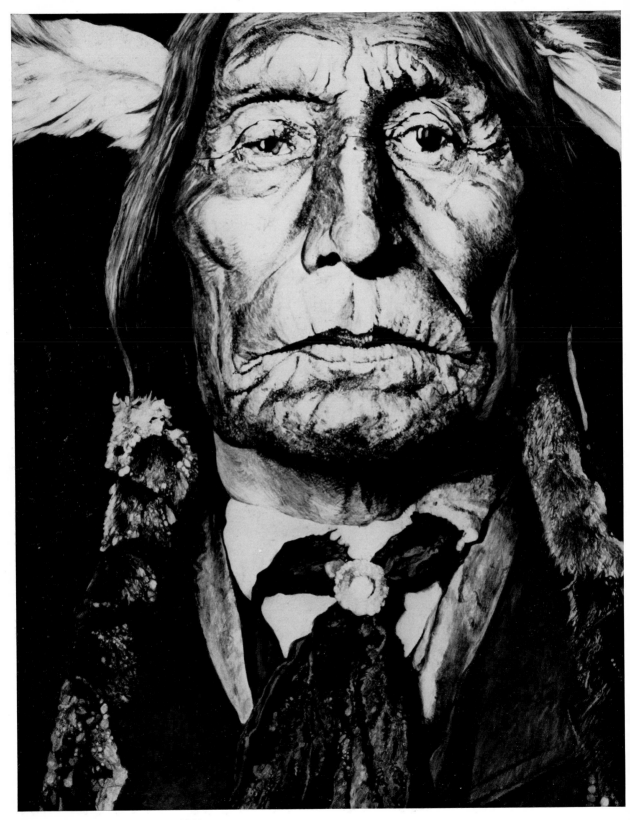

2 *Joseph Raffael* Cheyenne 1969

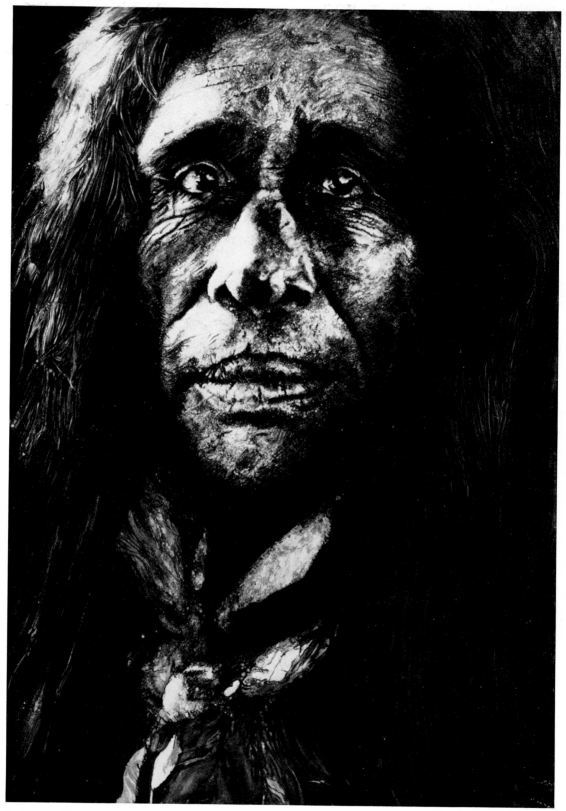

3 *Joseph Raffael* Pomo 1970

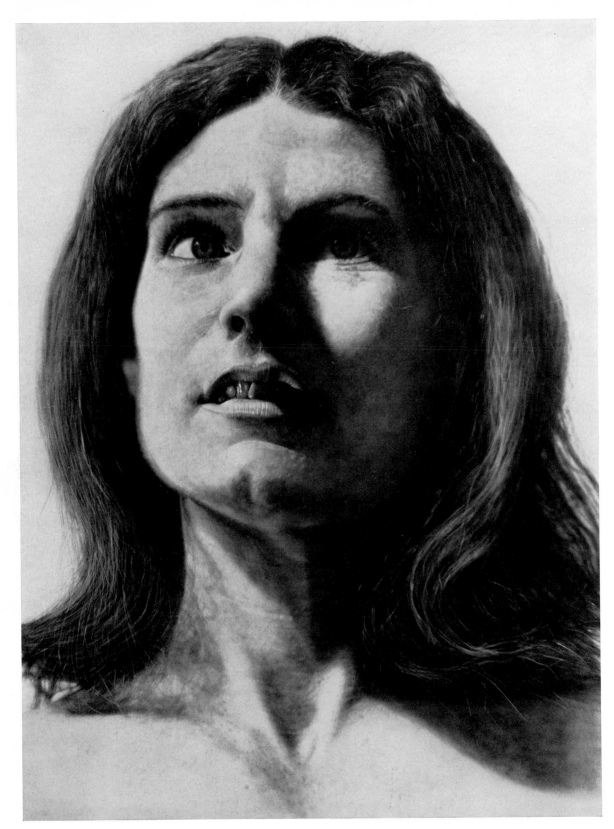

4 *Chuck Close* Nancy 1968

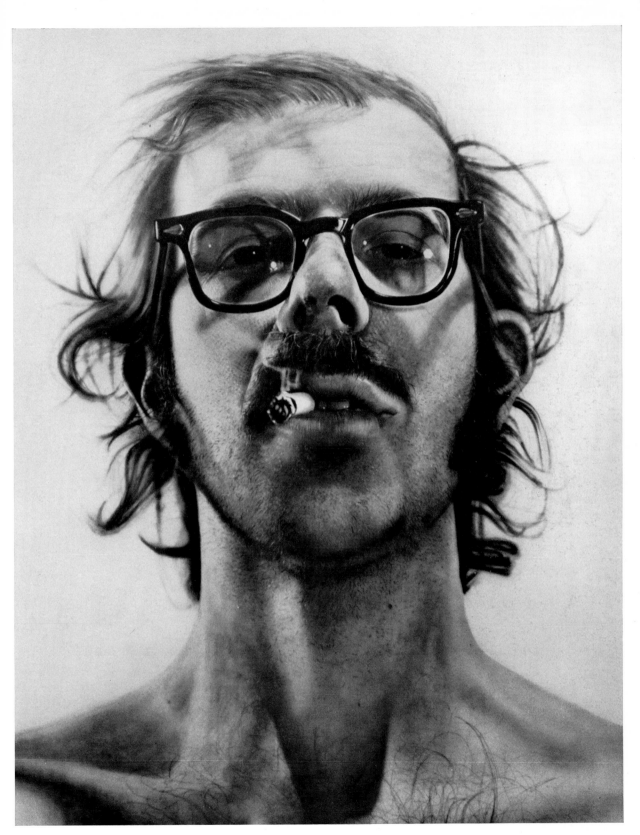

5 *Chuck Close* Self Portrait 1968

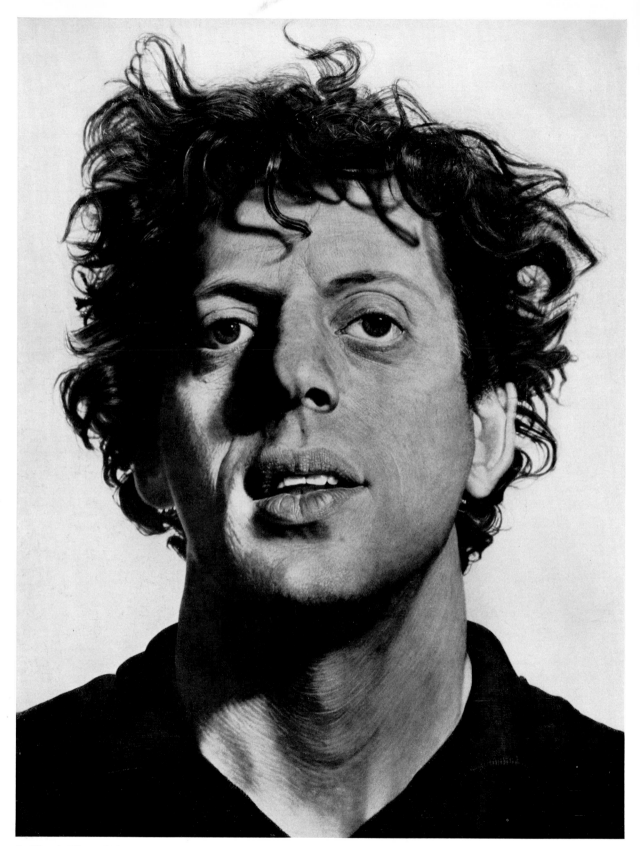

6 *Chuck Close* Phil 1969

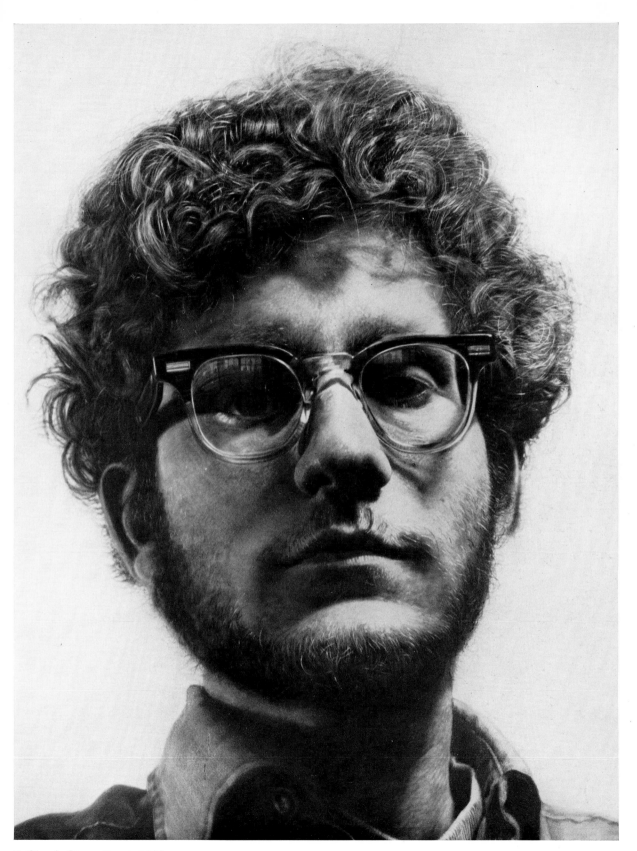

7 *Chuck Close* Frank 1969

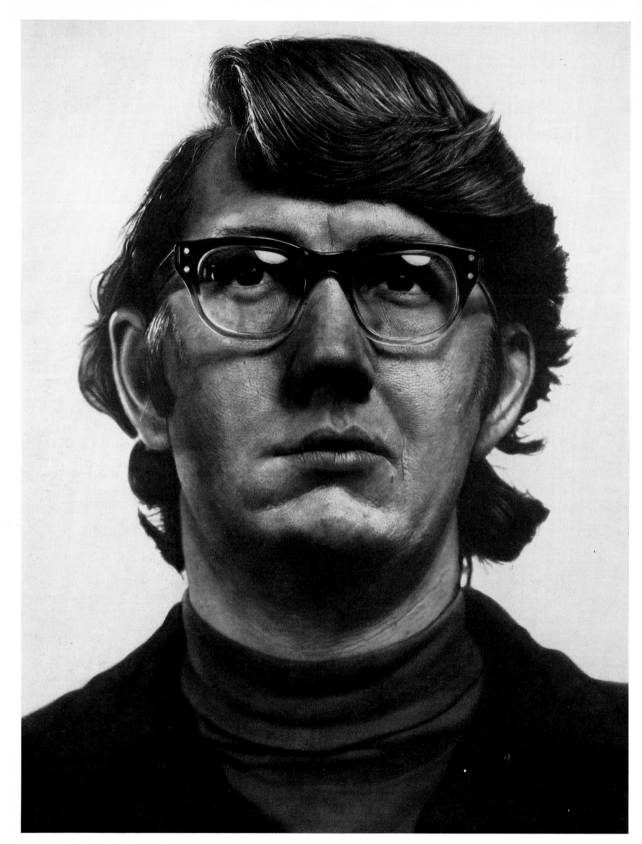

8 *Chuck Close* Kieth 1970

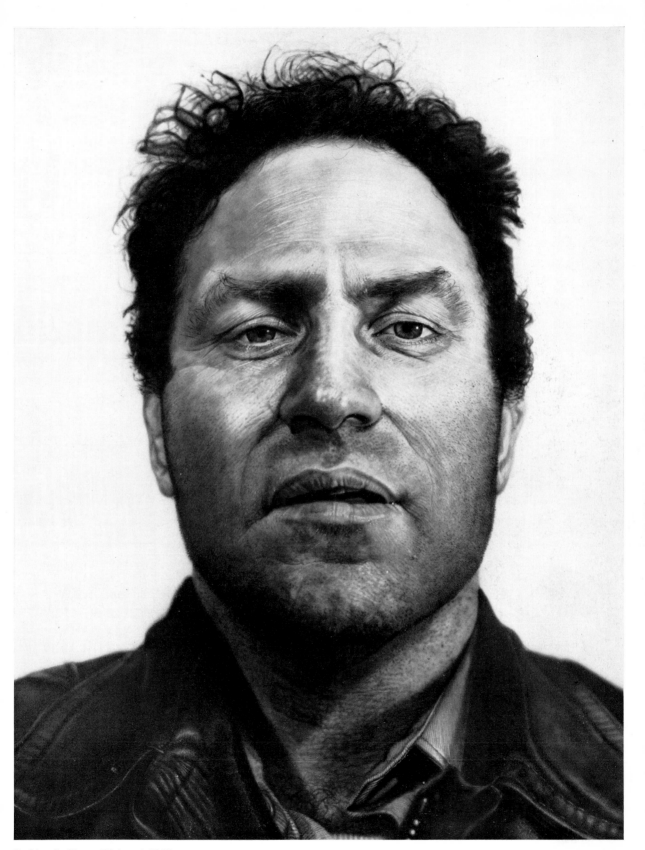

9 *Chuck Close* Richard 1969

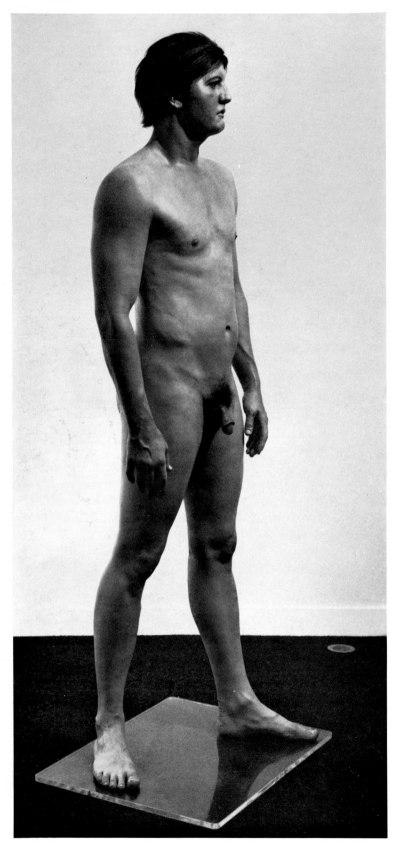

10 *John de Andrea* Untitled 1970

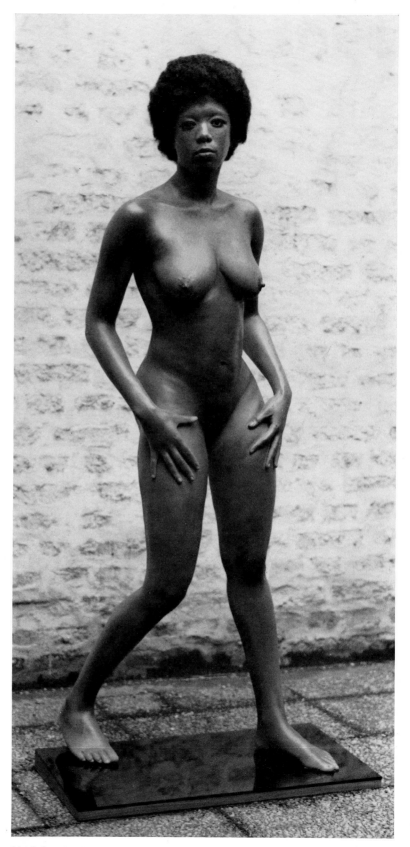

11 *John de Andrea* Untitled 1970

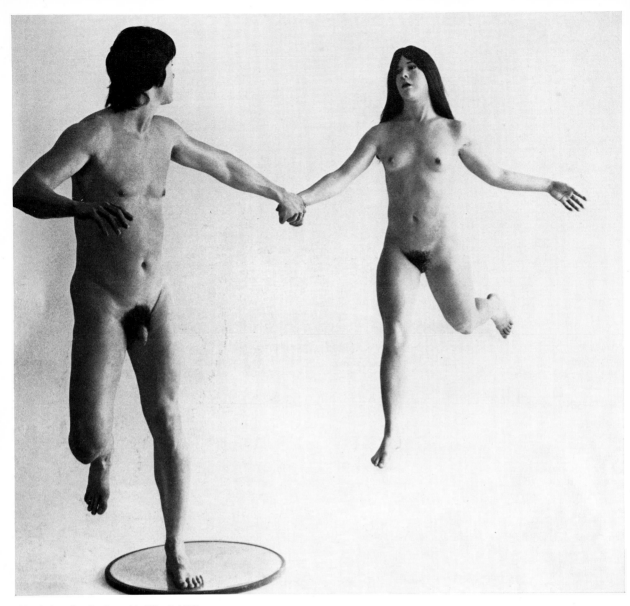

12 *John de Andrea* Untitled 1971

13 *John de Andrea* Untitled (Detail) 1970

14 *John de Andrea* Untitled 1971

15 *John de Andrea* Untitled 1971

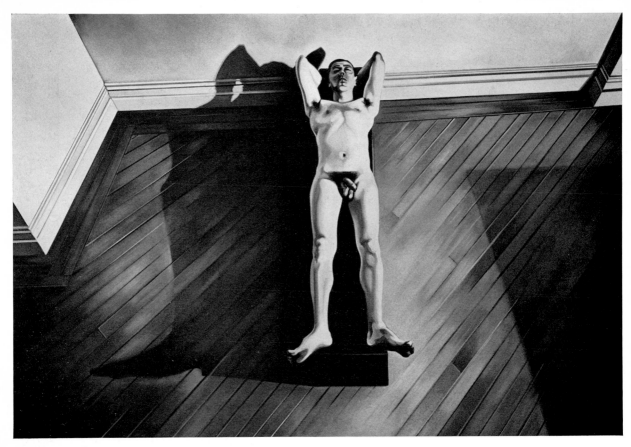

16 *Lowell Nesbitt* Studio Floor Nude 1969

17 *Lowell Nesbitt* Nude with Ladder 1969

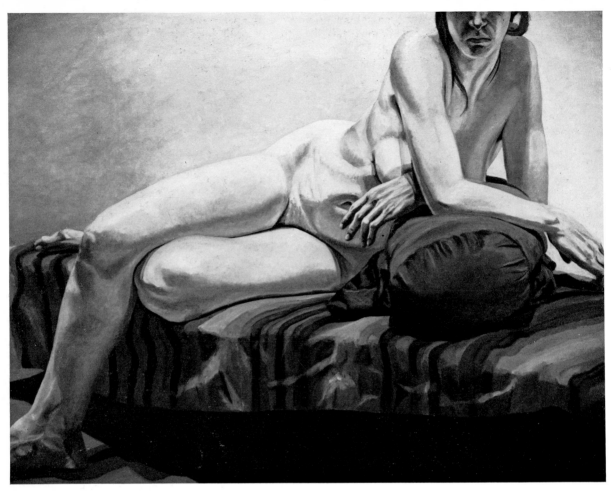

18 *Philip Pearlstein* Woman Reclining on Couch 1966

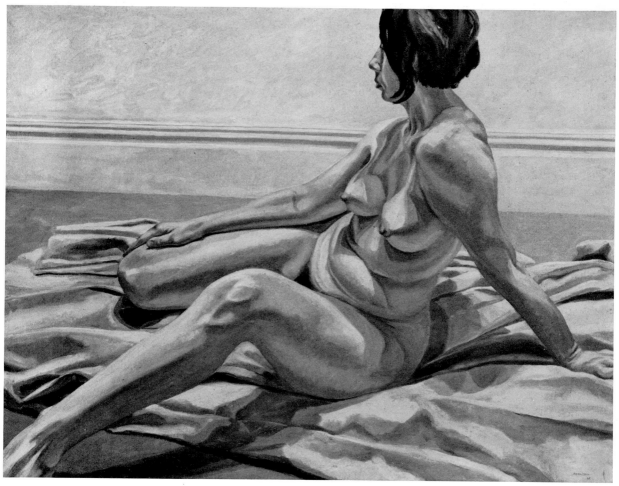

19 *Philip Pearlstein* Model in the Studio 1965

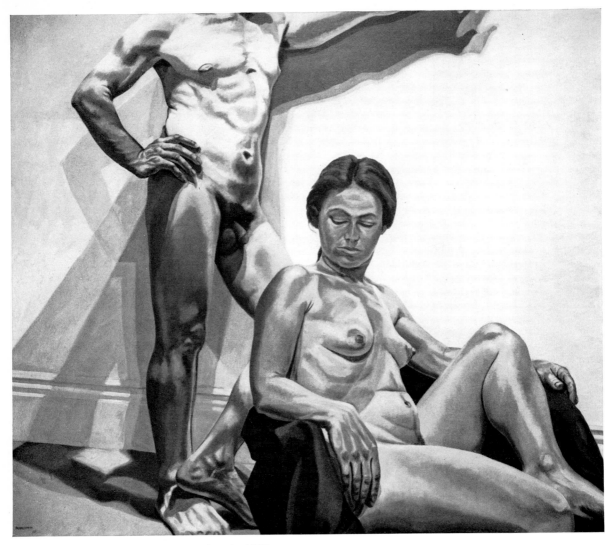

20 *Philip Pearlstein* Models in the Studio 1967

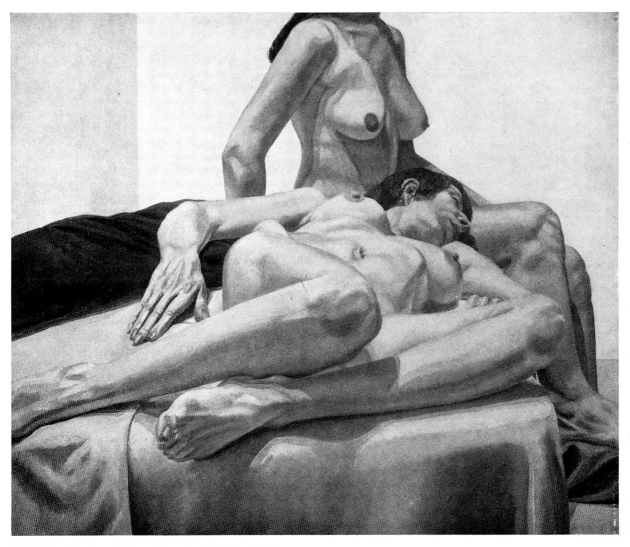

21 *Philip Pearlstein* Two Female Models 1967

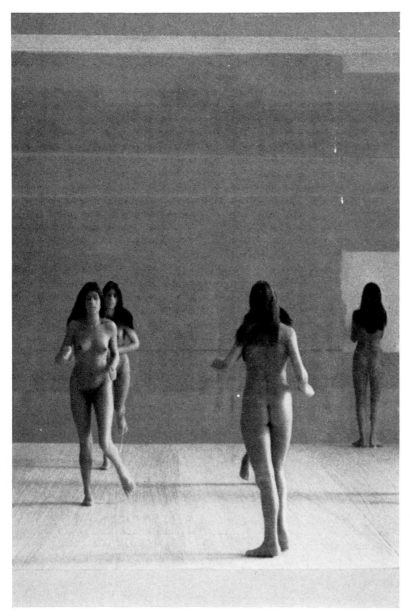

22 *Robert Graham* Untitled (Detail) 1970

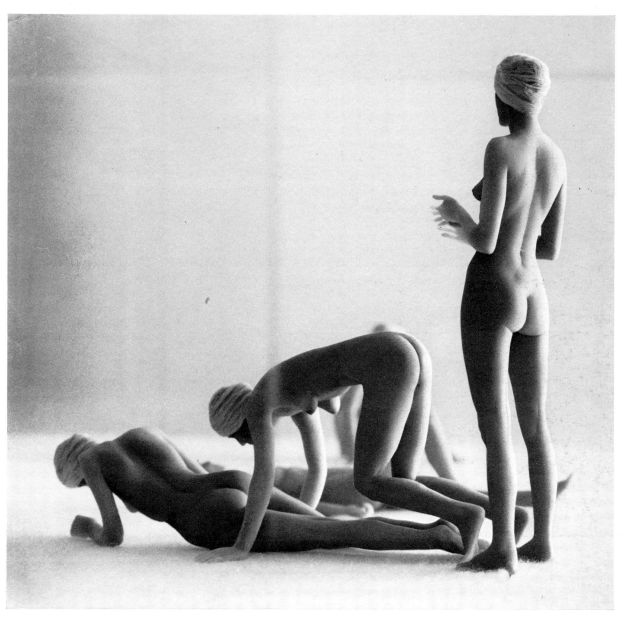

23 *Robert Graham* Untitled (Detail) 1970

24 *Jack Beal* Peace 1970

25 *Jack Beal* Madison Nude 1967

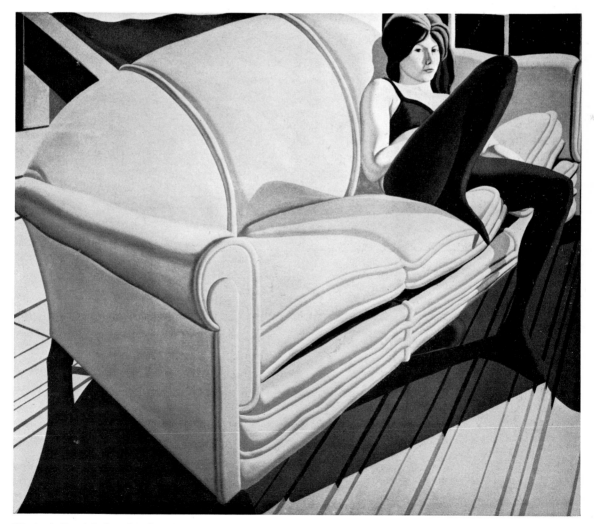

26 *Jack Beal* Sofa with Sondra 1968

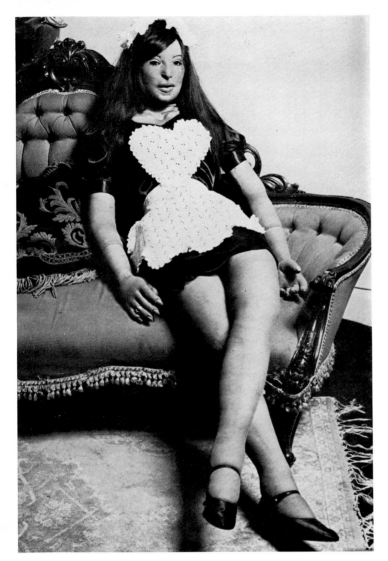

27 *Jann Haworth* Maid 1966

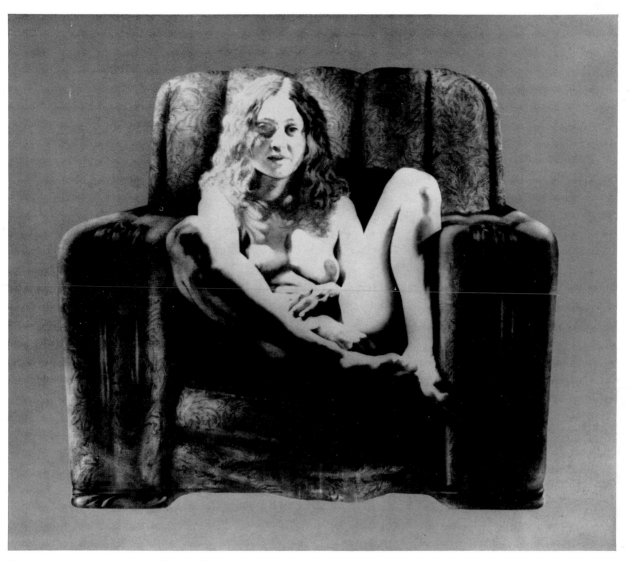

28 *Lawrence Dreiband* Untitled 1969

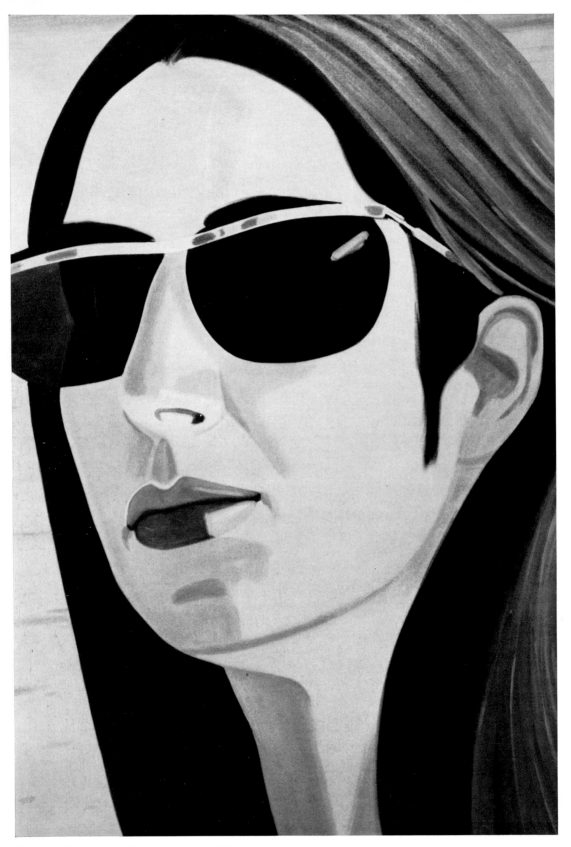

29 *Alex Katz* Ada with Sunglasses 1969

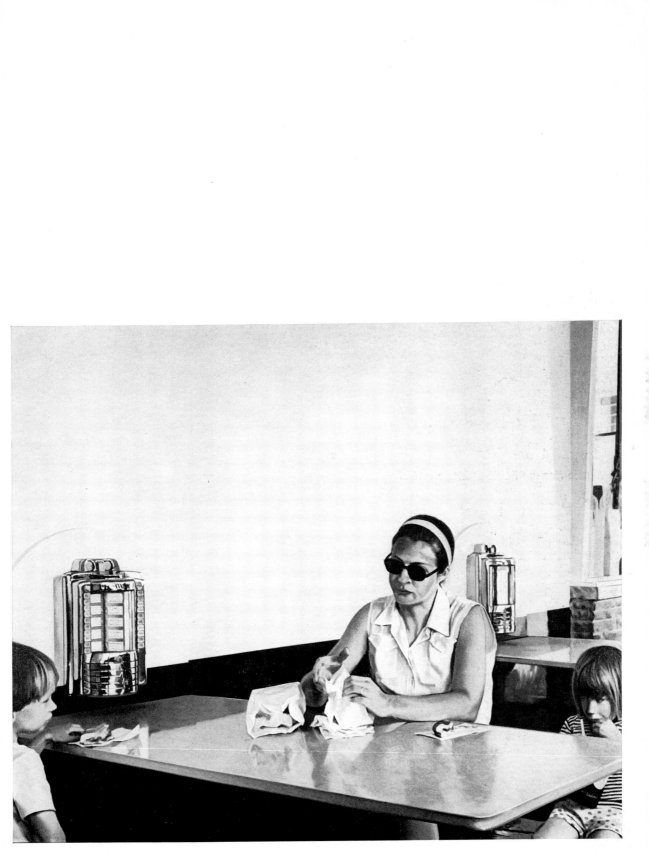

30 *Robert Bechtle* Foster's Freeze 1970

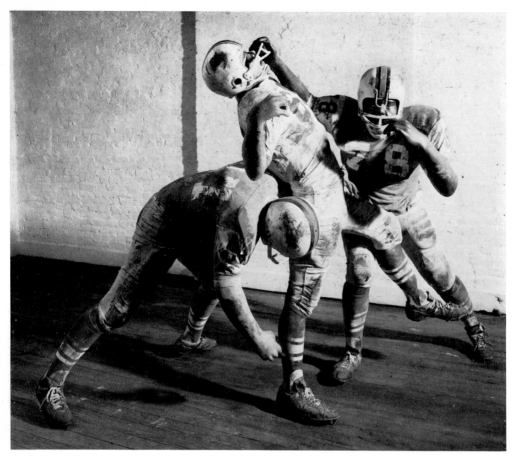

31 *Duane Hanson* Football Players 1969

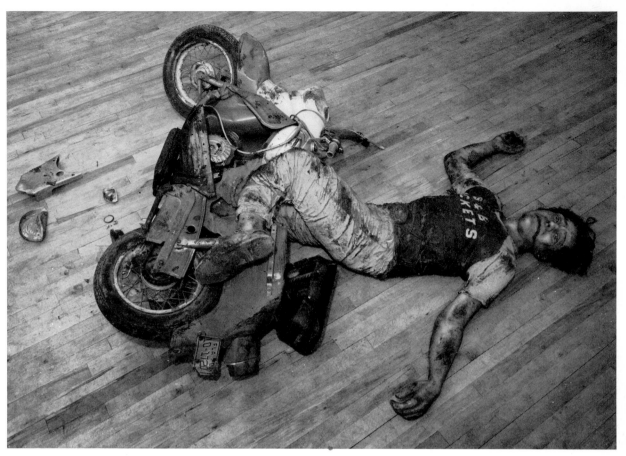

32 *Duane Hanson* Untitled 1969

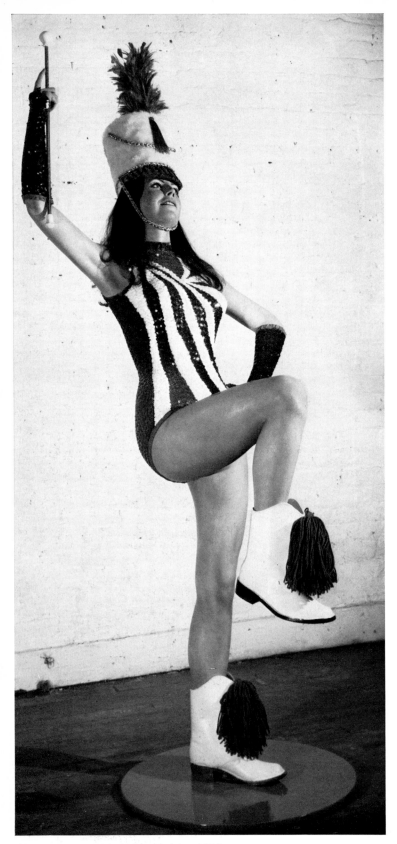

33 *Duane Hanson* Baton Twirler 1971

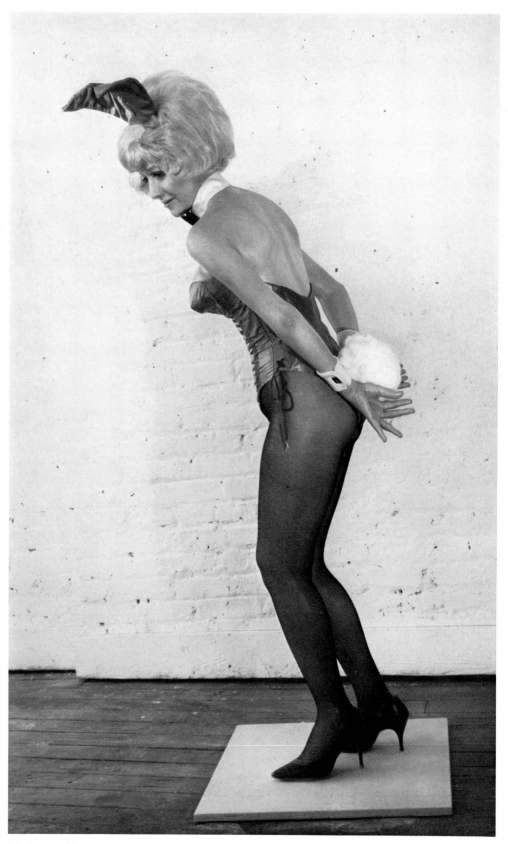

34 *Duane Hanson* Bunny 1970

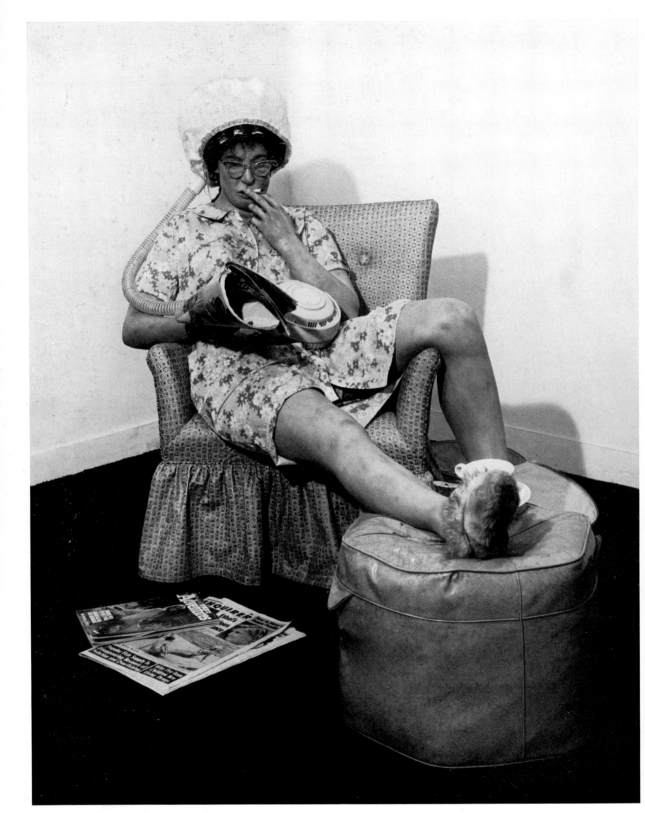

35 *Duane Hanson* Woman Reading 1970

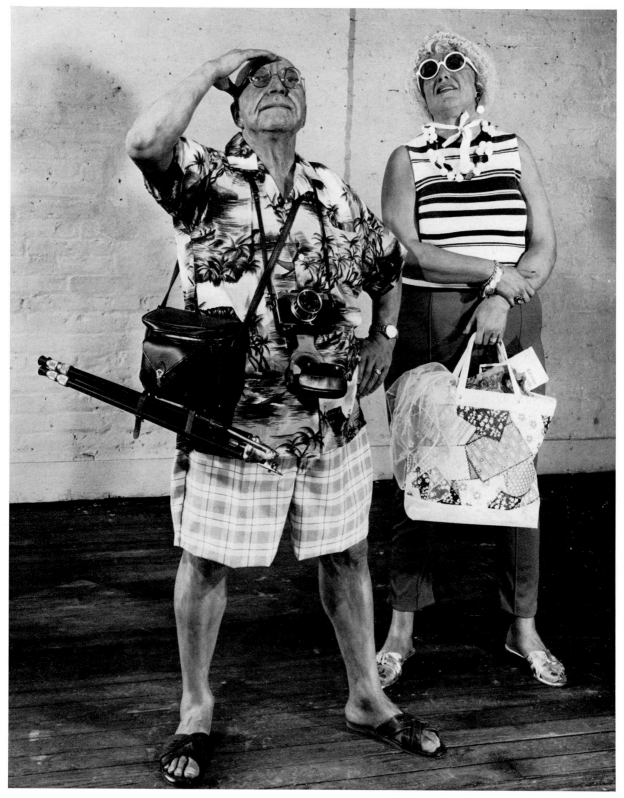

36 *Duane Hanson* Tourists 1970

37 *Duane Hanson* Portrait of Melvin Kaufmann 1971

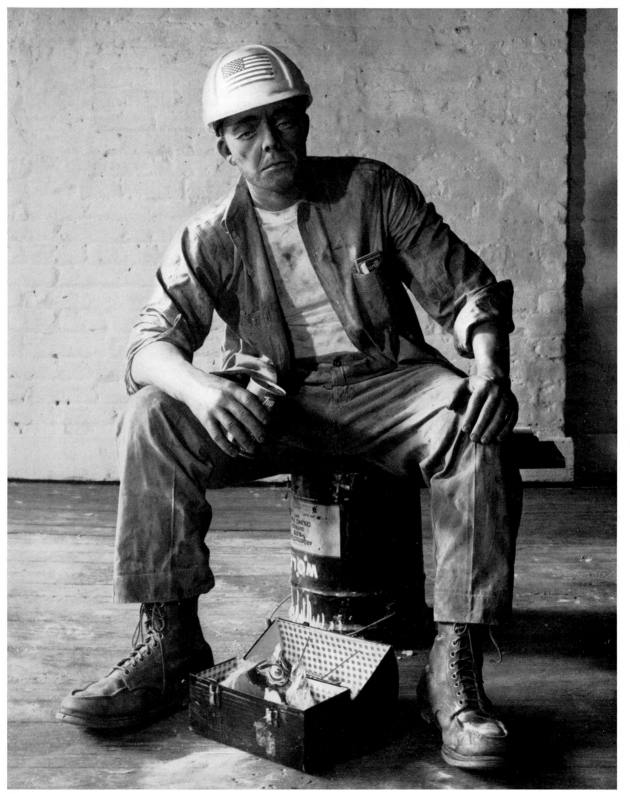

38 *Duane Hanson* Hardhat 1970

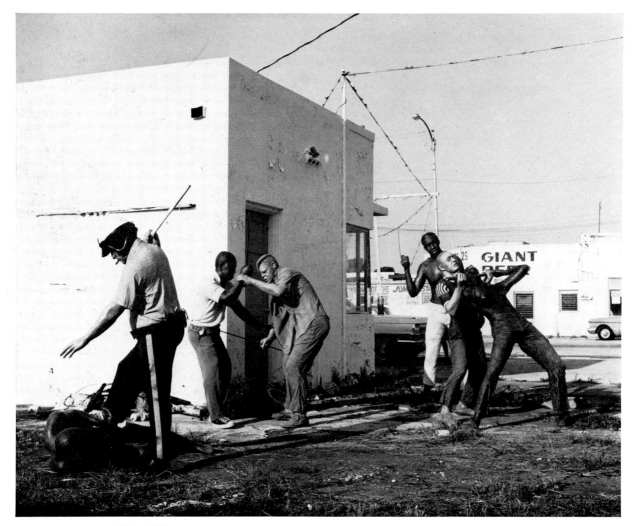

39 *Duane Hanson* Riot 1968

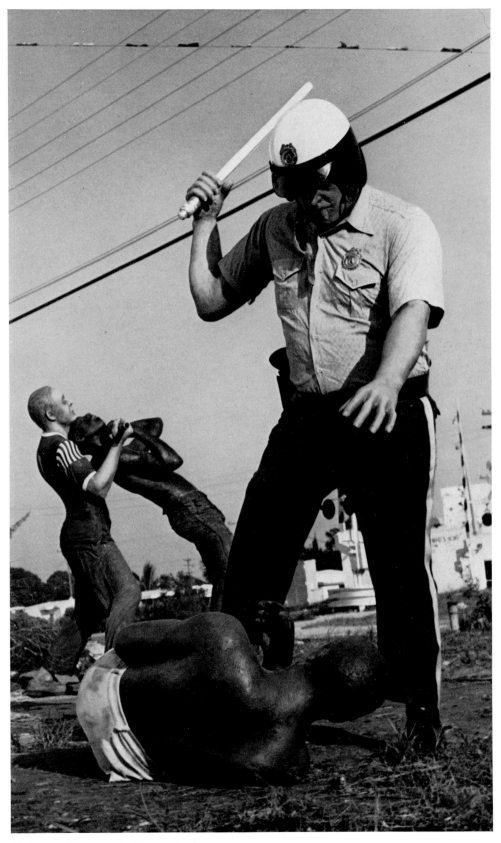

40 *Duane Hanson* Riot (Detail) 1968

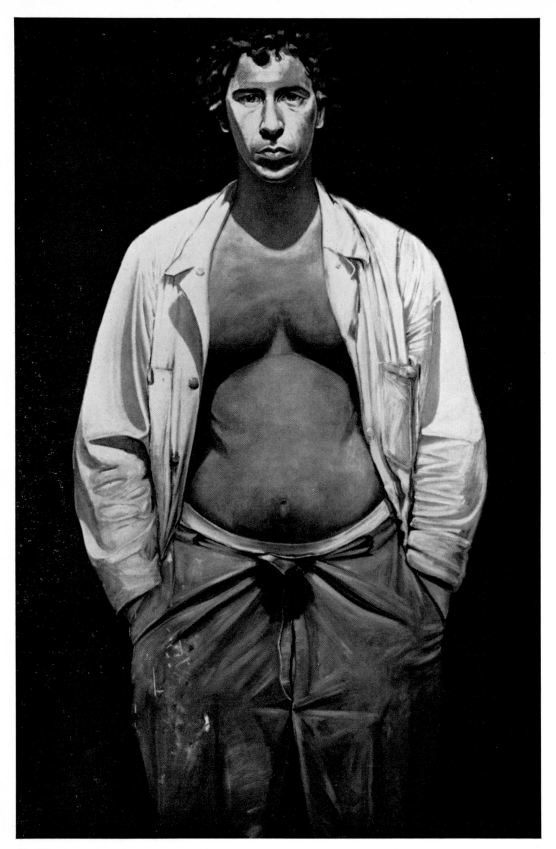

41 *Alfred Leslie* Self Portrait 1966/1967

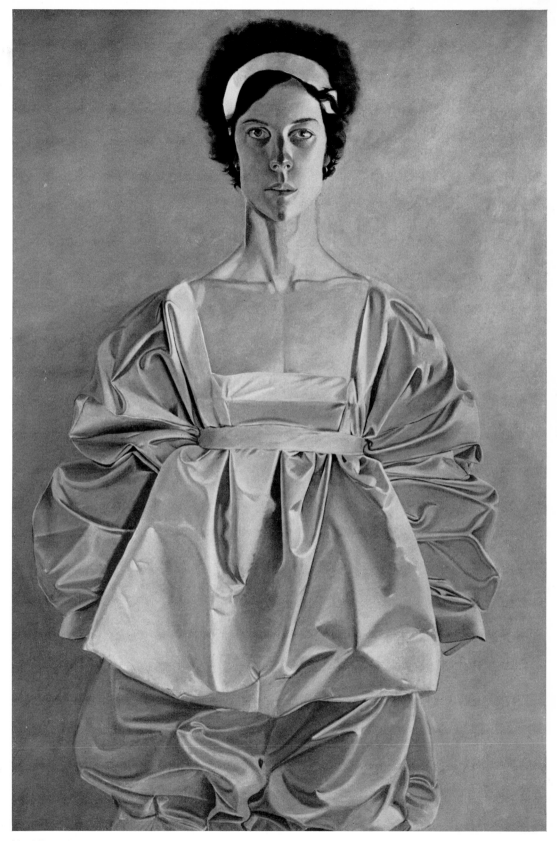

42 *Alfred Leslie* Constance West 1969

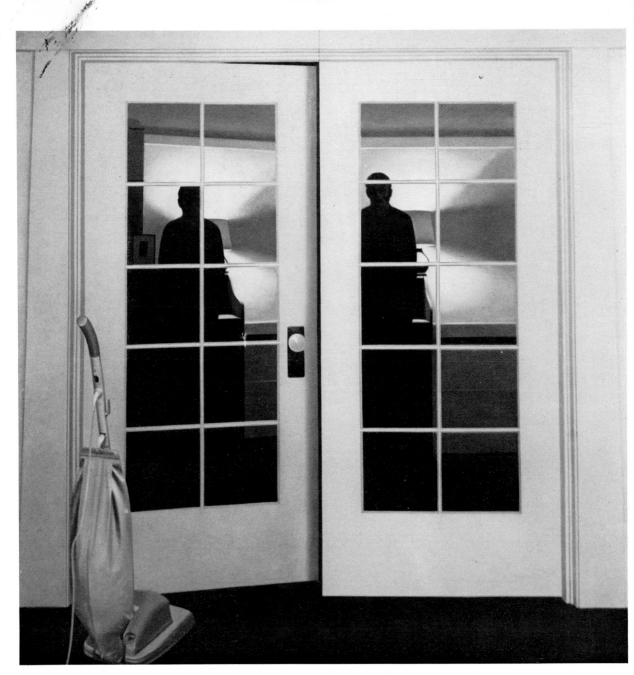

43 *Robert Bechtle* French Doors 1965

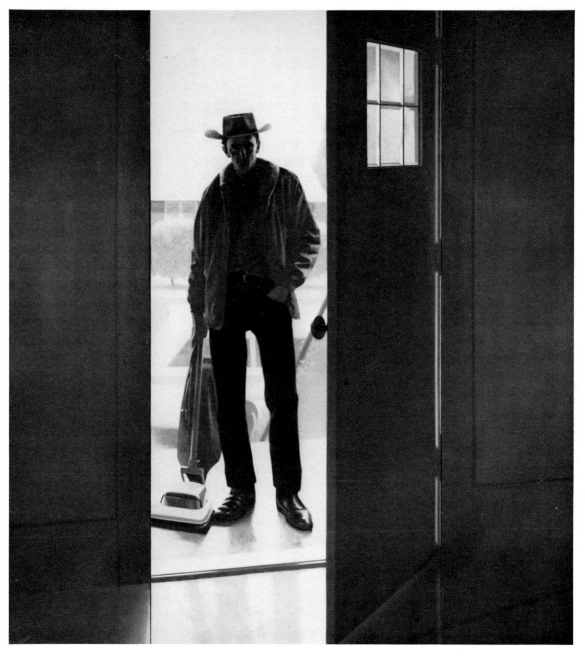

44 *Robert Bechtle* Hoover Man 1966

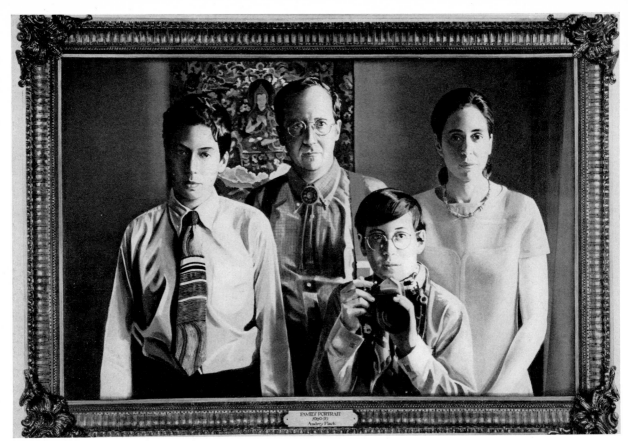

45 *Audrey Flack* Family Portrait 1969/1970

46 *Robert Bechtle* '61 Pontiac 1968/1969

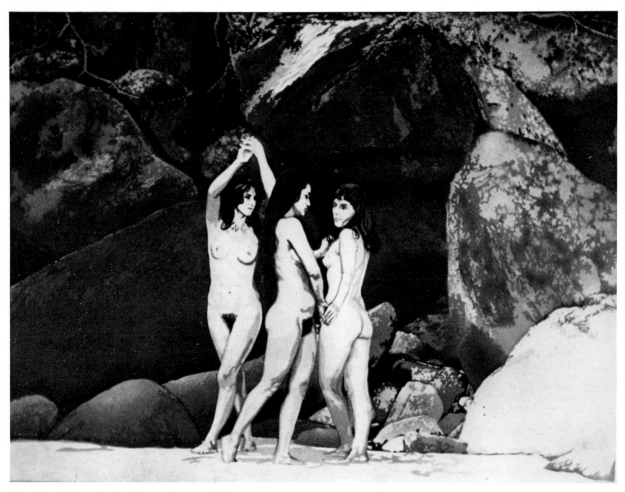

47 *John Clem Clarke* Three Graces 1970

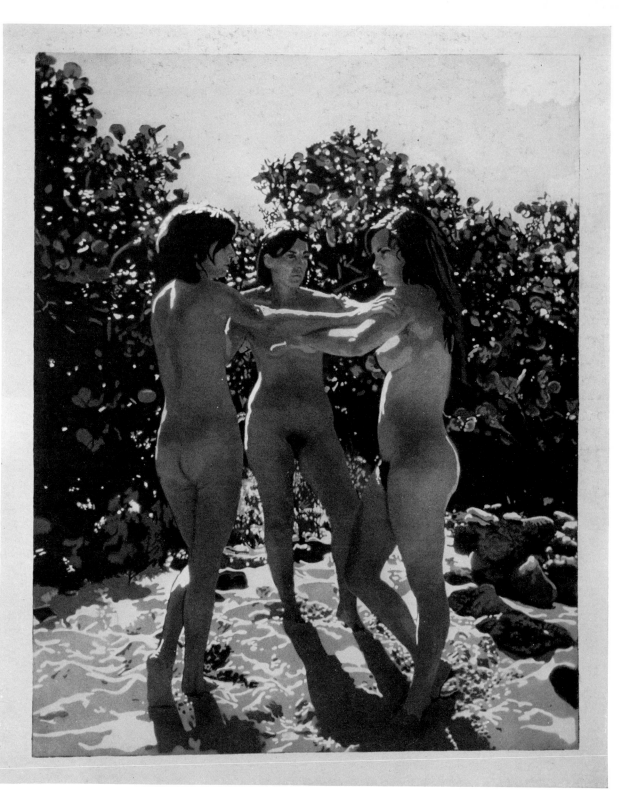

48 *John Clem Clarke* Three Graces 1970

51 *Gérard Gasiorowski* Le voyage de Mozart à Prague 1969

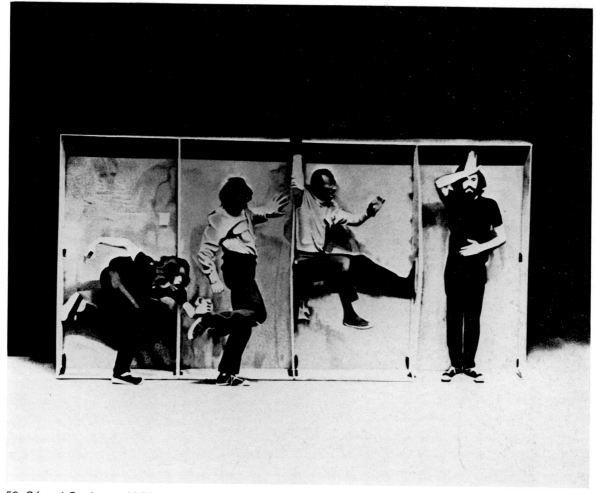

52 *Gérard Gasiorowski* Dix secondes conscientes 1970

53 *Gérard Gasiorowski* Dans les campagnes on voit partout des bicyclettes . . . 1966

54 *Gérard Gasiorowski* Untitled 1965

55 *Douglas Bond* Ace I 1968

56 *Douglas Bond* Dollie Ruth 1970

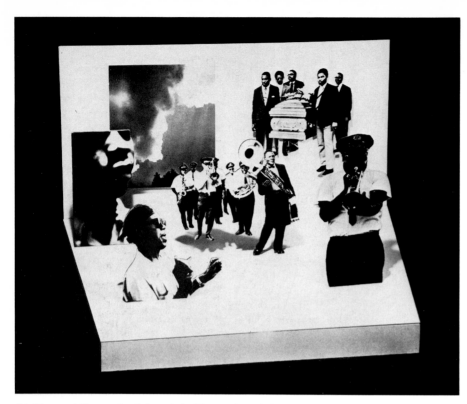

57 *Howard Kanowitz* A Death in Treme 1970/71

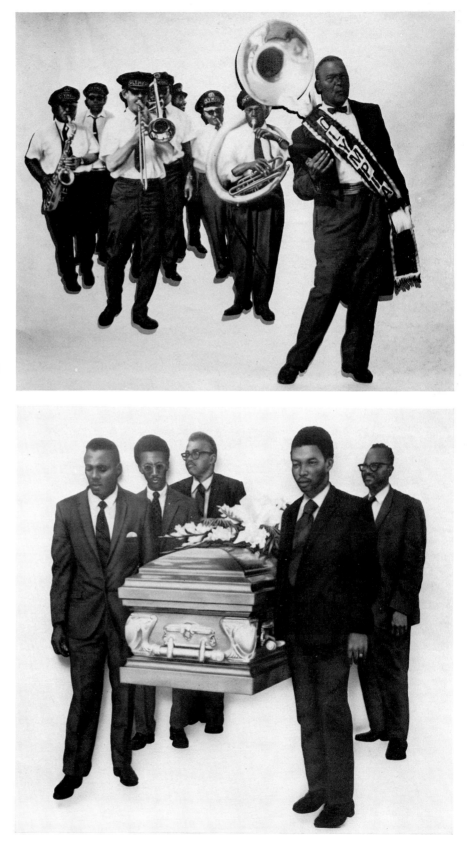

58 *Howard Kanowitz*
A Death in Treme (Detail)
1970/71

59 *Howard Kanowitz*
A Death in Treme (Detail)
1970/71

60 *Harold Bruder* Luncheon at Hay-Meadows 1969

61 *Harold Bruder* Canyon Encounter 1967

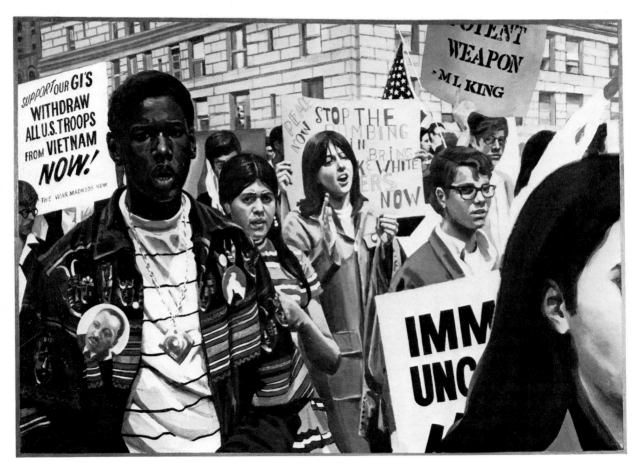

62 *Audrey Flack* War Protest March 1969

63 *Duane Hanson* War 1967

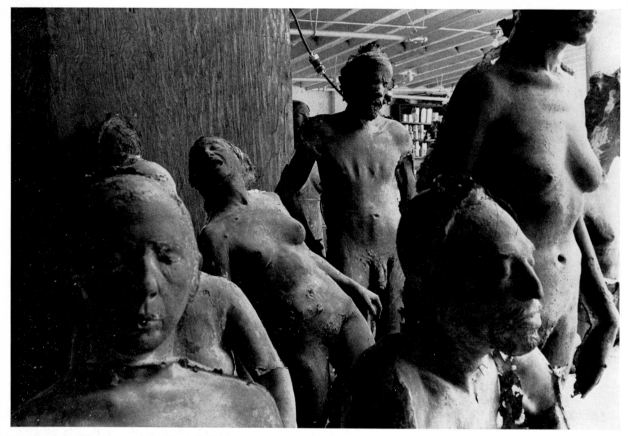

64 *Yehuda Ben-Yehuda* Untitled 1970

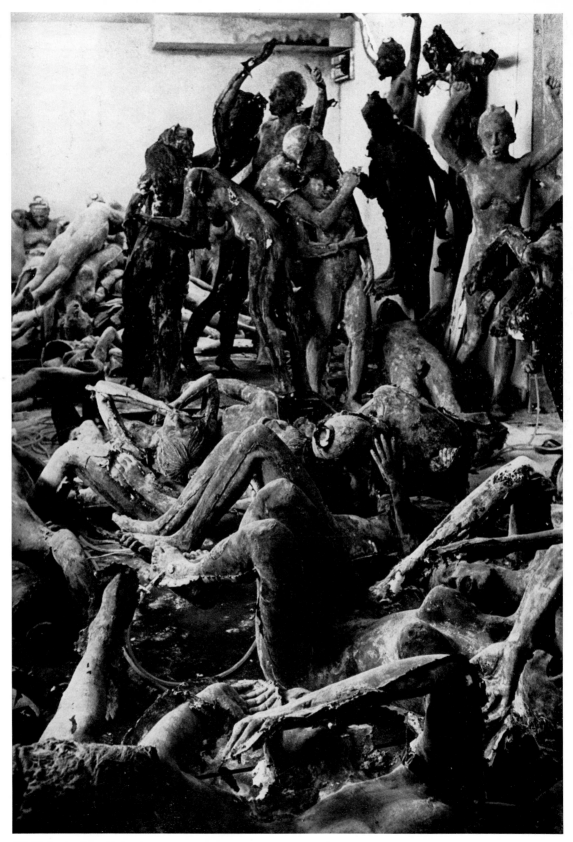

65 *Yehuda Ben-Yehuda* Untitled 1970

66 *Richard McLean* Untitled 1969

67 *Richard McLean* Still Life with Black Jockey 1969

68 *Richard McLean*
All American Standard Miss 1968

69 *Richard McLean*
Blue and White Start 1968

70 *Richard McLean* Synbad's Mt. Rainier 1968

71 *Noel Mahaffey* Untitled 1969

72 *Noel Mahaffey* Untitled 1969

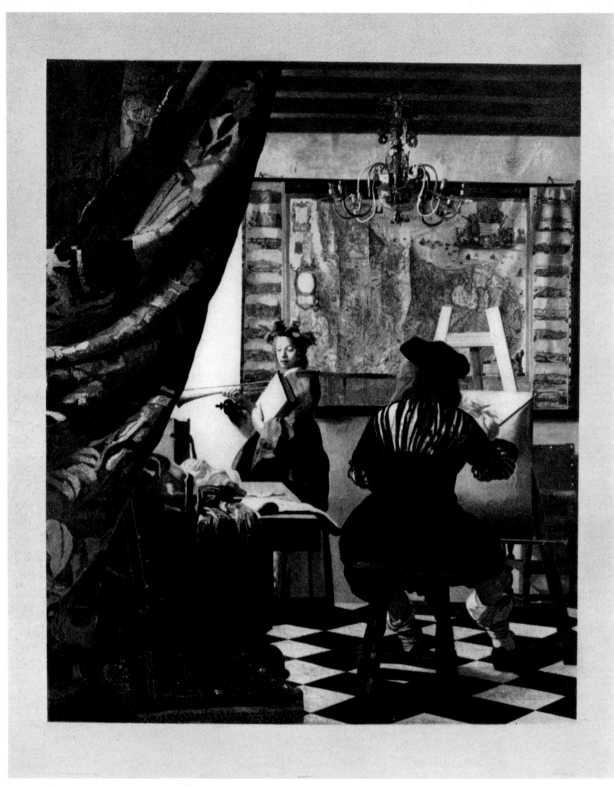

73 *Malcolm Morley* Vermeer – Portrait of the Artist in His Studio 1968

74 *John Clem Clarke*
An American Vermeer
1970

75 *George Deem*
Vermeer — Woman with Jug
1970

Artists' names for Fig 74 and 75
shuold be exchanged

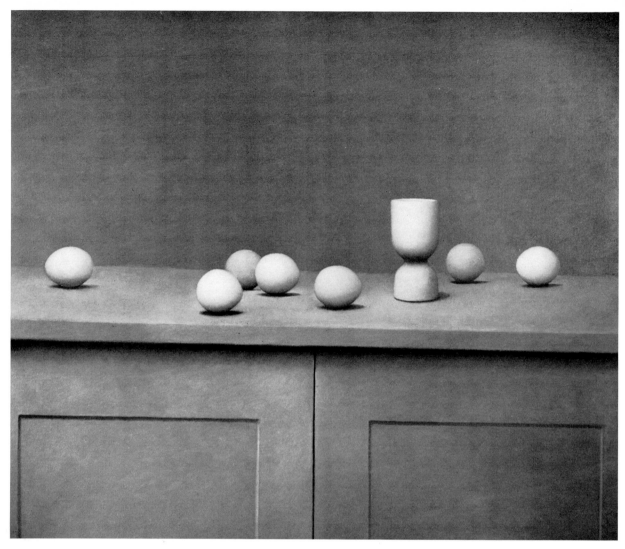

76 *William Bailey* Egg Cup and Eggs 1970

77 *Kurt Kay* For All Their Innocent Airs, They Know Exactly Where They're Going 1968

78 *Howard Kanowitz* Canvas Backs 1967

79 *Howard Kanowitz* Crown Jewel 1970

82 *John J. Moore* Cylinders 1969

83 *John J. Moore* Yellow Table 1970

84 *Richard Joseph* Blue Roll 1968

85 *Richard Joseph* Drawing Table 1968

86 *Howard Kanowitz* The Painting Wall and Water Bucket Stool 1968

87 *Lowell Nesbitt* Plaster and Pipes 1967

88 *Sylvia Mangold* Floor Corner 1969

89 *Yvonne Jacquette* The Barn Window Sky 1970

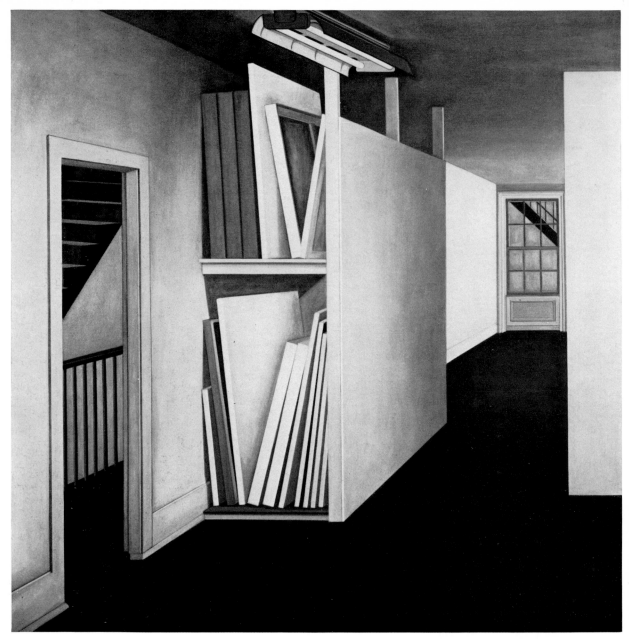

90 *Cecile Gray Bazelon* Studio Two 1970

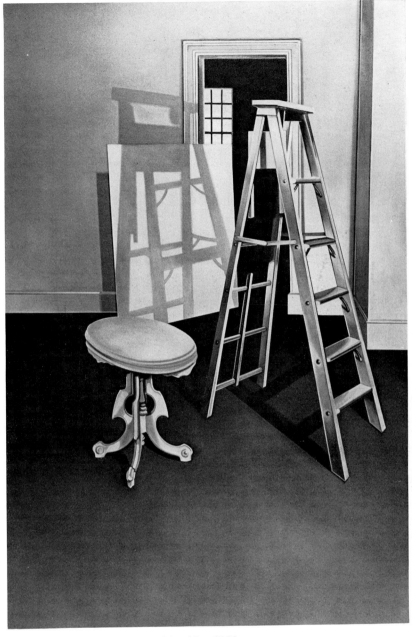

91 *Lowell Nesbitt* Table and Ladder 1966

92 *Paul Sarkisian* Untitled (Mendocino) 1970

93 *Alan Turner* Untitled 1969

94 *Bruce Everett* Doorknob 1970

95 *Bruce Everett*
Towel Rack 1970

96 *Bruce Everett*
Untitled 1969

97 *Don Nice* Turnip 1967

98 *Joseph Raffael*
Autumn Leaves
(Homage to
Keturah Blakeley) 1970

99 *Alex Katz* Iris 1967

100 *Gabriel Laderman* Still Life 1963/1964

101 *Gabriel Laderman* Still Life (Homage to David „Death of Marat") 1969

104 *John Salt* Untitled 1968/1969

105 *John Salt* Blue Interior 1970

106 *John Salt* Arrested Vehicle (Writing on Roof) 1970

107 *Alfred Leslie* The Killing of Frank O'Hara 1969

108 *Don Eddy* Volkswagen: R. F. 1970

109 *Don Eddy* Volkswagen: R. F. 1970

110 *John Salt* Arrested Vehicle Broken Window 1970

111 *Don Eddy* Jeep L. P. 1970

112 *Richard Estes* Store Front 1968

113 *Richard Estes* Untitled 1970

114 *Ralph Goings* Airstream 1970

115 *Ralph Goings* Untitled 1969

116 *Robert Bechtle* '67 Chrysler 1967

117 *Robert Bechtle* '60 T-Bird 1967/1968

118 *Malcolm Morley* First Class Cabin 1965

119 *Malcolm Morley* ''Amsterdam'' in front of Rotterdam 1966

120 *Don Eddy* Untitled 1969

121 *Don Eddy* Untitled 1969

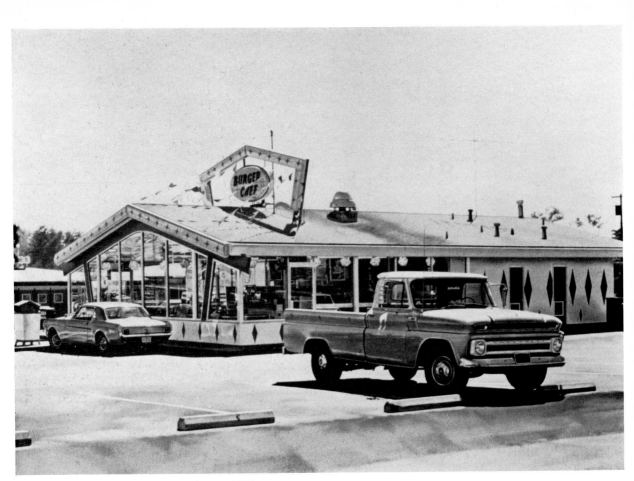

122 *Ralph Goings* Burger Chef Chevy 1970

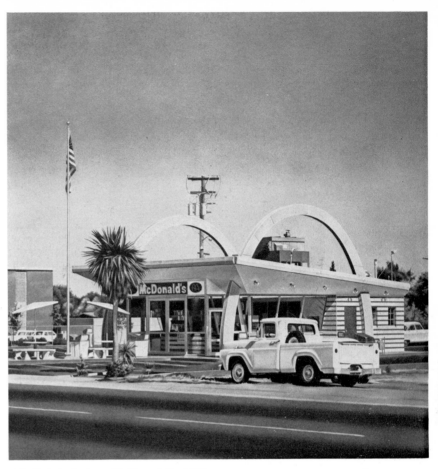

123 *Ralph Goings* McDonald's 1970

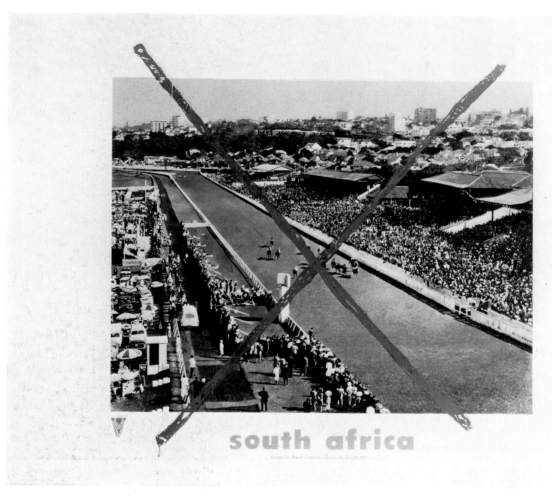

south africa

124 *Malcolm Morley* Racetrack 1969/70

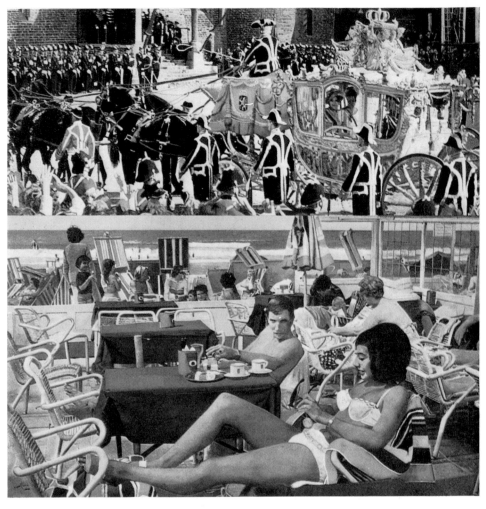

125 *Malcolm Morley* Coronation and Beach Scene 1969

1

128 *Richard Estes* Untitled 1967

129 *Richard Estes* No. 2 Broadway 1968

130 *Richard Estes* Untitled 1970

131 *Richard Estes* Untitled 1970

133 *Robert Cottingham* Untitled 1969

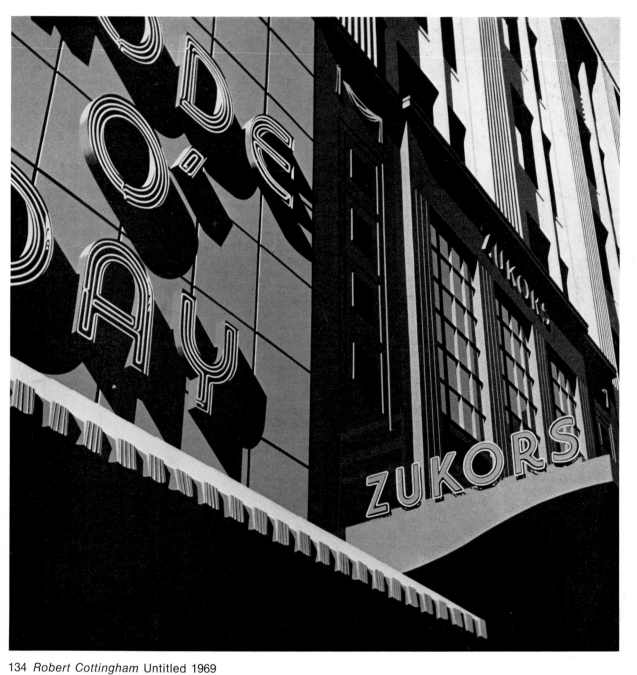

134 *Robert Cottingham* Untitled 1969

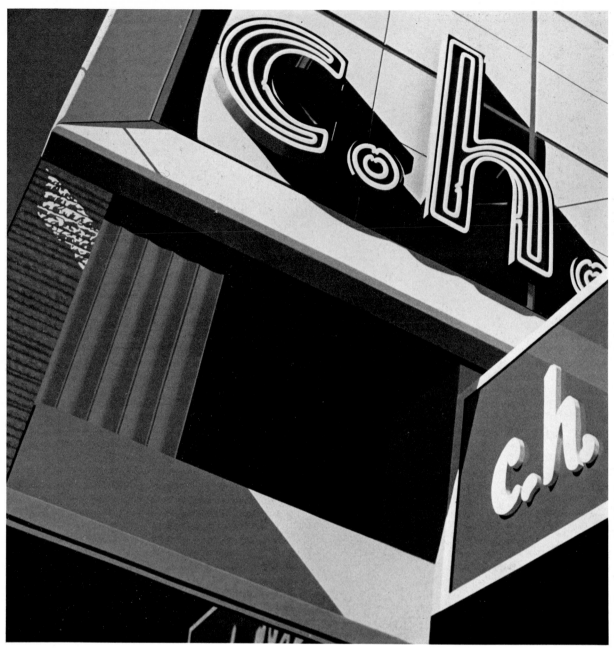

135 *Robert Cottingham* c. h. 1970

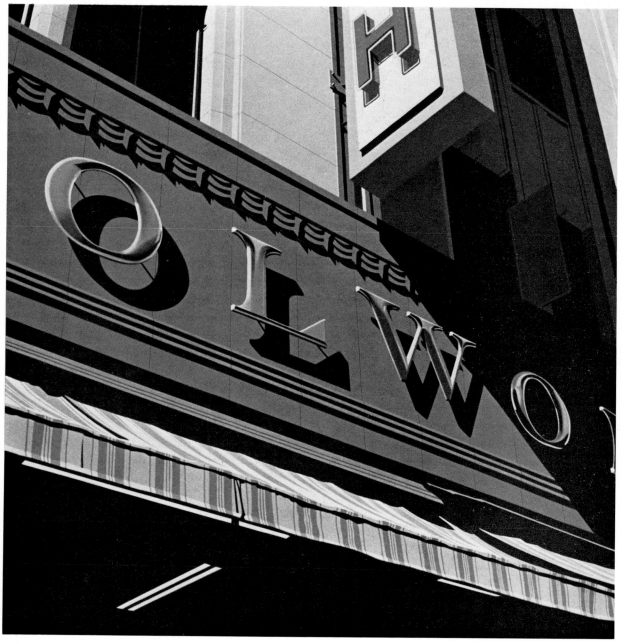

136 *Robert Cottingham* Woolworth's 1970

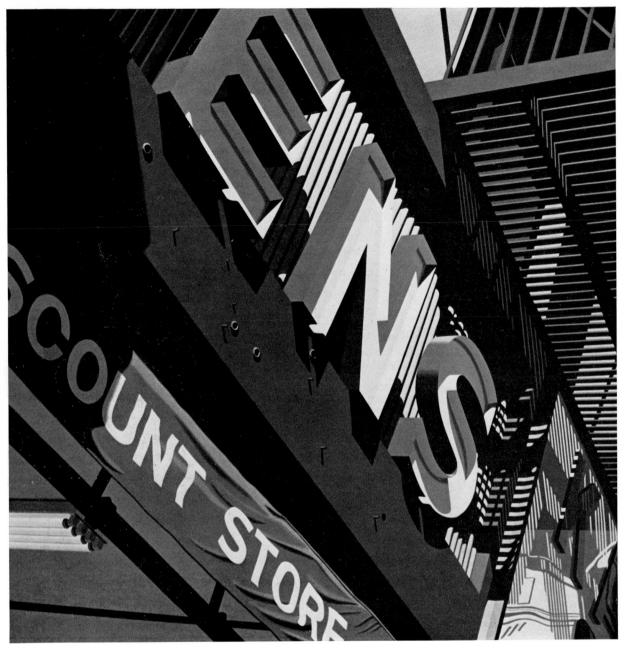

137 *Robert Cottingham* Discount Store 1970

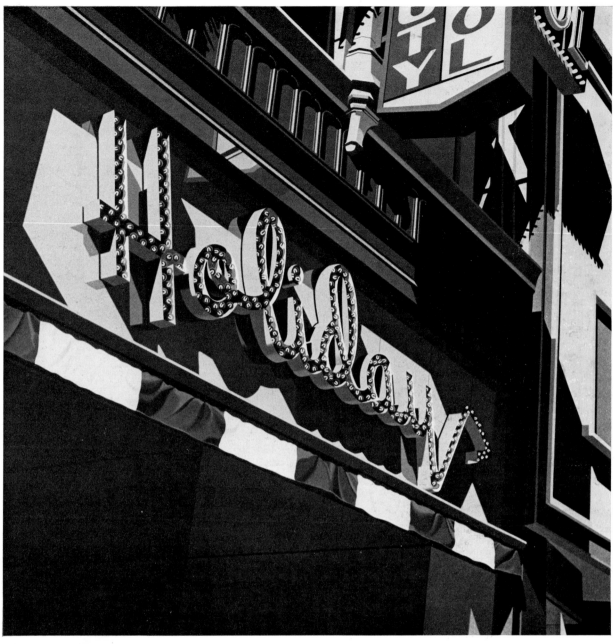

138 *Robert Cottingham* Holiday's 1970

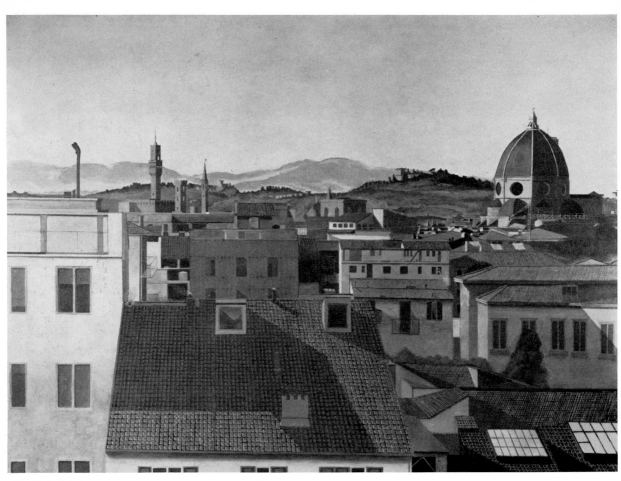

139 *Gabriel Laderman* View of Florence 1962/1963

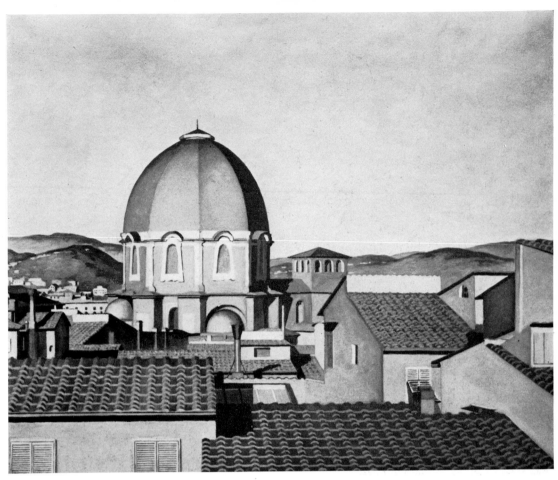

140 *Bruno Civitico* Florence – San Lorenzo 1968

141 *Gabriel Laderman* Downriver 1964

142 *Gabriel Laderman* View of Baton Rouge with St. James Cathedral 1967

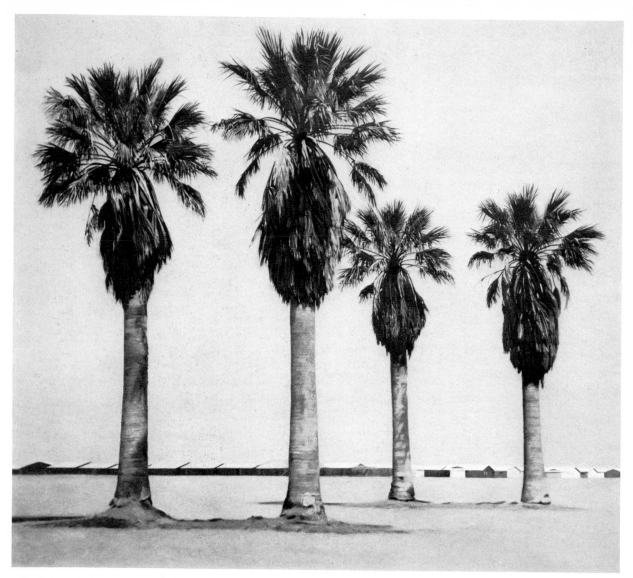

143 *Robert Bechtle* Four Palm Trees 1969

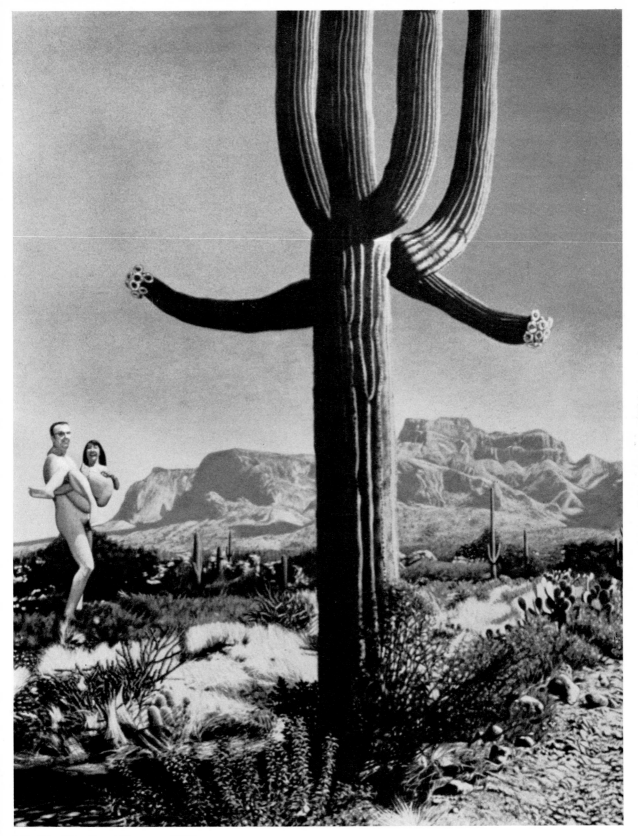

144 *Douglas Bond* Saguaro 1970

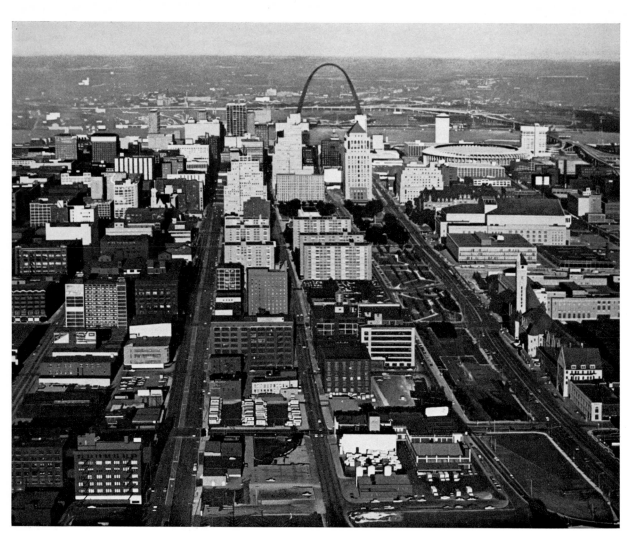

145 *Noel Mahaffey* St. Louis, Missouri 1971

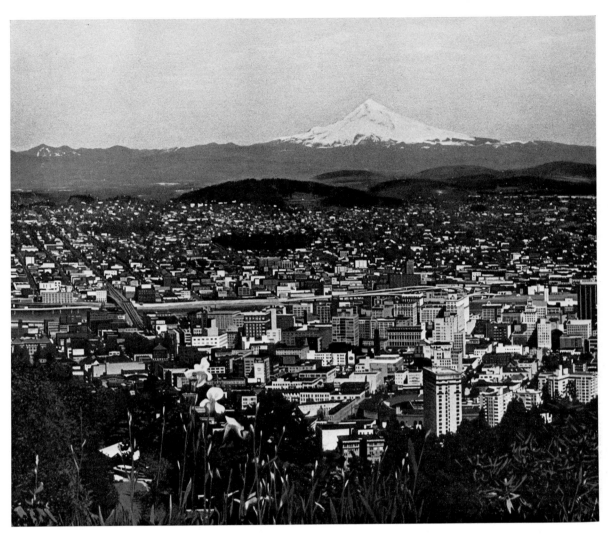

146 *Noel Mahaffey* Portland, Oregon 1970

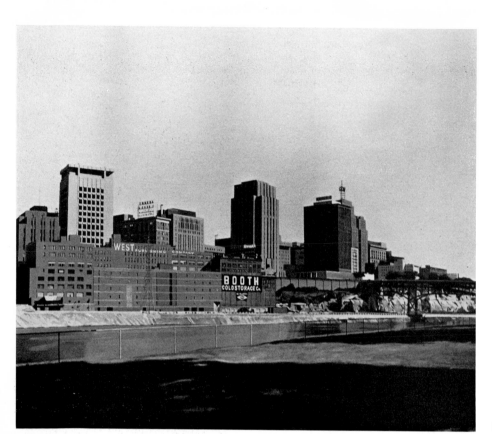

147 *Noel Mahaffey*
St. Paul, Minnesota 1970

148 *Noel Mahaffey*
Minneapolis,
Minnesota 1970

149 *Noel Mahaffey* Waco, Texas 1970

150 *Lowell Nesbitt* Work Stages – V. A. B. 1970

151 *Lowell Nesbitt* Lift-Off 1970

152 *Lowell Nesbitt* Moon Craters 1969